FAVERSHAM
From Old Photographs

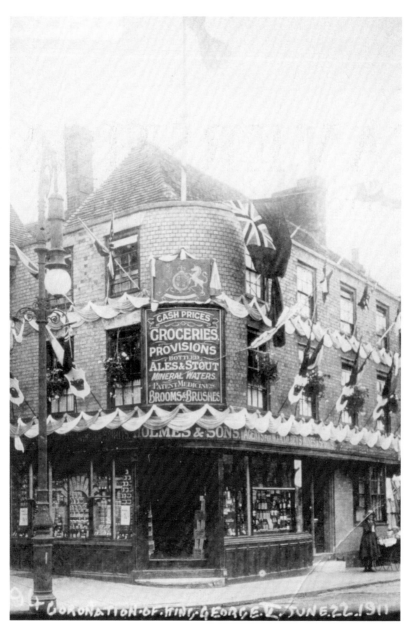

Holmes & Sons, the grocers at No. 1 Court Street, is decorated with flags and bunting, on Thursday 22 June 1911, to celebrate the coronation of King George V.

FAVERSHAM
From Old Photographs

PETER KENNETT

AMBERLEY

First published by Tempus Publishing Limited, 2004
This edition published 2009

Copyright © Peter Kennett, 2009

Amberley Publishing
Cirencester Road, Chalford,
Stroud, Gloucestershire, GL6 8PE

British Library Cataloguing in Publication Data.
A catalogue record for this book is available from the British Library.

ISBN 978-1-84868-467-6

Typesetting and origination by Amberley Publishing
Printed in Great Britain

CONTENTS

The Lightning Express at Faversham.

ACKNOWLEDGEMENTS

Most of the photographs in this book are from picture postcards and other material in my own collection. However, I wish to thank the following for making loans: Jack and Brenda Ramsden, Bert Jemmett, Geoff Lennard and Cliff Court. Thank you Rob and Kim for introducing me to the fascinating hobby of postcard collecting.

I am most grateful to the many people who have supplied me with information and to the *Faversham News*, for permission to reproduce a number of photographs which appeared in the 'memories' page. I am also indebted to Arthur Percival for his book, *Old Faversham* and Eric Swain for his book, *Faversham in Old Photographs*, plus the many people who have written *Faversham Papers* for The Faversham Society, which provided me with the necessary information to compile this book. A special thanks to Sidney Clark for his wonderful articles about Faversham events and characters, which appear in the monthly journal, *Bygone Kent*.

A thank you to Rob Duncan, a friend for many years, for reading the captions and suggesting some amendments.

I have endeavoured to obtain permission to use material that may still be under copyright and apologise for any omissions in this respect.

My thanks go to Doug and Pam Brown for all their help and encouragement with correcting the manuscript and belief that all this accumulated information was always going to be a book. Finally, a very big thank you to Doug for his introduction.

North View (taken in the year 1735) of Faversham Abbey, founded by ing Stephen. AD 1148 Inscribed to the Inhabitants of the Town

INTRODUCTION

My wife and I first discovered Faversham back in the mid-sixties. We hadn't long been married and had arrived there in search of our dream home which was not one of the beautifully maintained timber frame buildings of which the town had and still has numerous examples. Instead, our hearts were set upon one of the old sailing barges that were still to be found making the occasional visit, be it with engine rather than sail, to unload their various freight at the creek side wharves behind lower West and Abbey Street.

We have often spoken since of that first chilly autumn day's walk from the railway station, with its coal fires in the waiting rooms, down through Preston Street to the stilted Court House which appeared, to us anyway, to be the living heart of the place. Our overriding impression was one of a quaint little country market town that the rest of the world had either never found, or had simply left behind.

We wouldn't have been aware at that time, of course, that to the north of the very waterway that we were exploring there lived a young man, with whom I was later destined to work for many many years. This is the man whose all consuming interest and affection for his hometown has culminated, some thirty years later, in this very book.

Peter's enthusiasm and passion for the history and folklore of his birthplace has taken him to all corners of the British Isles seeking out old photographs, postcards

and newspaper cuttings, to say nothing of the personal recollections of some of the 'old characters' of the Faversham area itself, some of whom are still with us, some sadly passed on.

On reflection, it is obvious to me that all this accumulated information was a book waiting to happen and I for one am extremely glad that it has eventually come to fruition. Please turn the following pages and, in the knowledgeable company of Peter Kennett, disappear for a while into the town of Faversham and the surrounding villages, just as they were but a short time ago.

Douglas Brown

What ! Come Home ?
Not likely, when I'm at
Faversham !

The Streets and Roads of Faversham

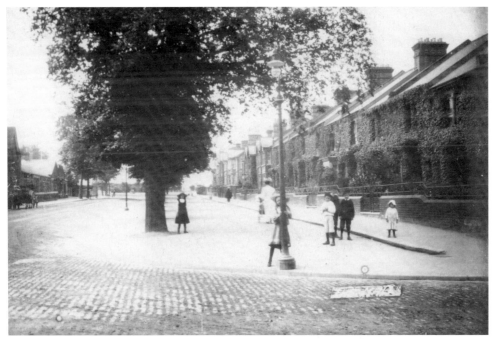

The Mall looking towards the London Road in 1906. An Edwardian lady takes a leisurely stroll, while children in their Sunday best pose for, or hide from, the photographer.

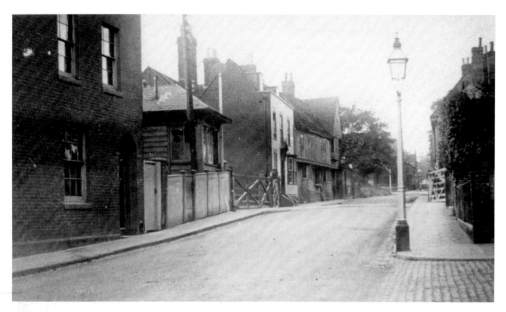

The level crossing at the top of Preston Street in 1894. Across the railway line on the left of the picture stands the old forge, with Preston Lane just beyond. In 1897 a new railway station was built and a subway took the place of the level crossing.

The top of Preston Street in the early 1890s. On the left stands Delbridge House, on the right is Chase House and in the middle is a delightful little house that sadly had to be demolished when the subway was built to enable the traffic to enter Preston Street from Forbes Road.

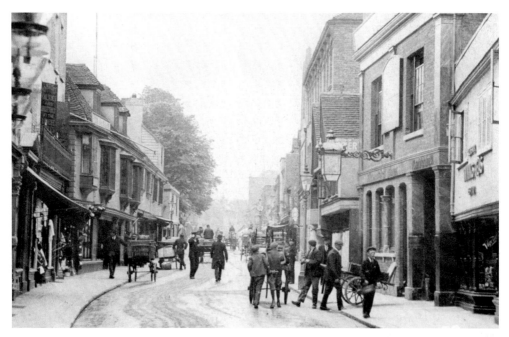

The bottom of Preston Street looking towards Station Road in 1900. A busy scene, with tradesmen and barrow boys going about their business. On the right stands The Dolphin Hotel with its ornate gas lamp. A huge tree stands in the grounds of Gatefield House, the home of Dr Sidney Alexander (Alexander Centre).

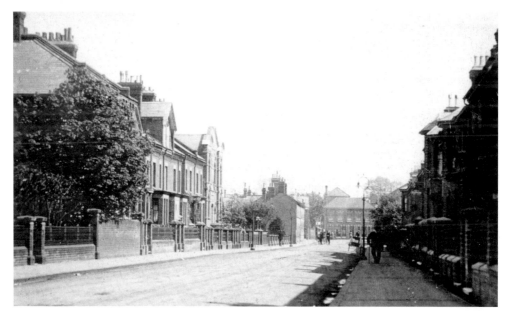

Stone Street looking towards Preston Street in 1918. A scene that has changed very little, except that the tall Bible Christian Methodist church on the left-hand side of the street has been demolished to make way for an extension to the Cottage Hospital.

The bottom of Ospringe Road looking towards South Road in 1908. The boys on the right of the picture, with their trolley made out of old wheels, head for the top of St Ann's Road to have fun coasting down the hill.

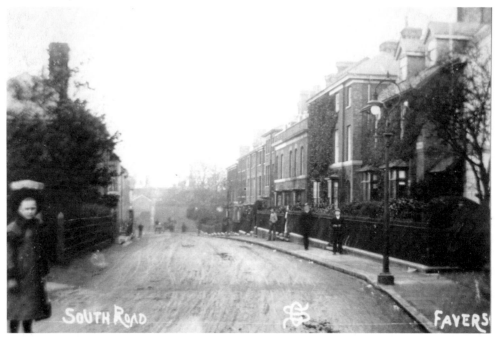

At the turn of the century, with few cars to worry about, a little girl happily poses for the photographer in South Road.

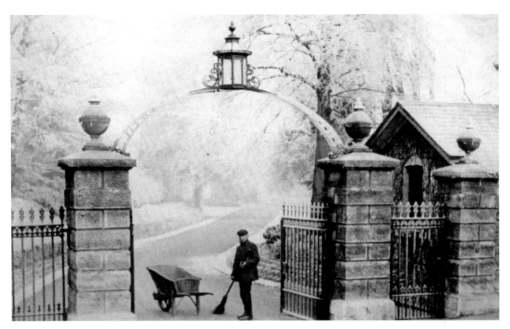

A snow covered St Ann's Park, with its ornamental gates, *c.* 1900. This was the home of gunpowder making, the Chart Mills and the Kings Mills set inside the park. When entering St Ann's Park by the drive from South Road these mills stood on the left and right, around 100 yards off the drive, surrounded by very large elm trees.

Many of the mills had lovely surroundings. Inside St Ann's Park there were ponds and streams which were fed from the ponds at Ospringe and the springs in the willow beds. Powder-punts were used to transport the gunpowder barrels to waiting barges at Faversham Creek.

Upper St Ann's Road in 1905. On the left of the picture, you can just make out the roof of the old grammar school. The building was demolished to make way for housing. Children stop playing on the corner leading to Athelstan Road, while the photographer captures the scene.

Lower St Ann's Road looking towards the bottom of Ospringe Road, *c.* 1907. A little girl shields her eyes from the sun while, behind her, tradesmen are busy selling their wares.

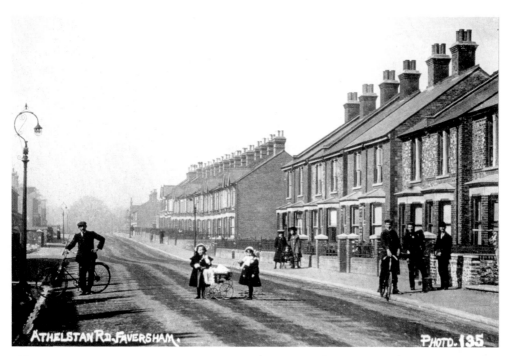

Athelstan Road looking towards St Ann's Road in 1905. A delightful scene with children playing in the middle of the road with their pram and dolls while local lads, with their cycles, look on.

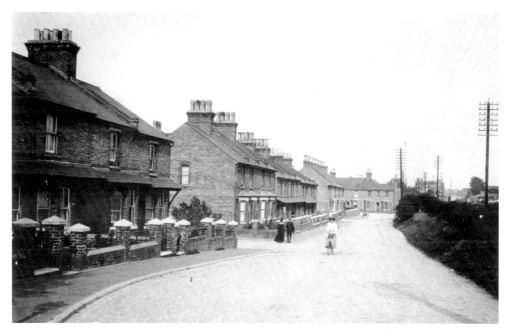

School Road looking towards Saxon Road, *c*. 1906. On a fine summer's day a lady in a large hat and long Edwardian dress cycles in the middle of the road. In the distance on the right stands Delbridge House, once the home of the station master.

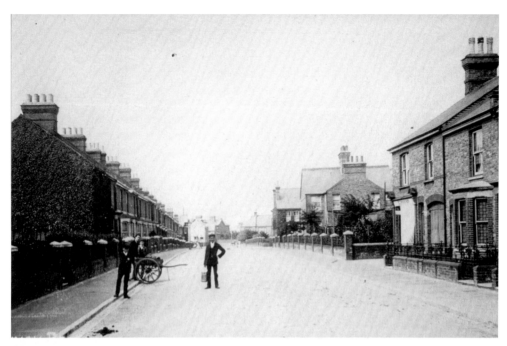

Saxon Road, *c.* 1908. On the right of the picture E. Croucher has his shop window blind down, perhaps it is early closing or a Sunday. In the distance on the left stands E. Fuller & Sons, builders, decorators and undertakers.

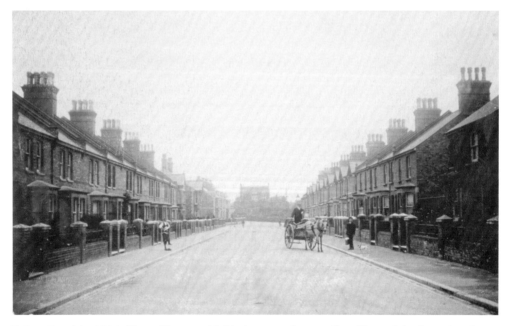

Briton Road in 1906. The milkman with his horse and cart sells milk straight from the churn. The entrance to Roman Road, on the left, and Delbridge House, in the centre, are little changed in ninety years.

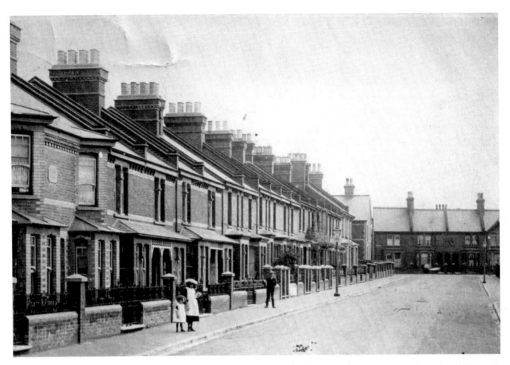

Roman Road, *c*. 1908. A view that has changed very little over the years but for the children's fashions which appear to suggest a more genteel way of life.

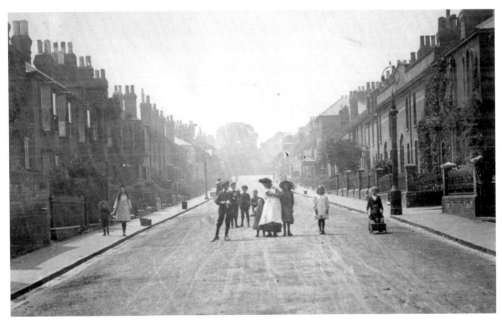

St Mary's Road looking towards Station Road in 1904. Great excitement sweeps through the road – word spreads that the photographer is coming and soon boys and girls line themselves across the road, ready to say 'Cheese'.

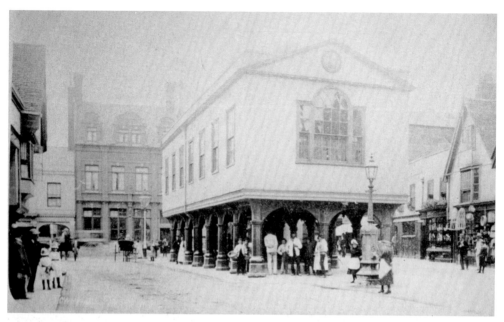

Market Place, *c.* 1900. Shopkeepers and local characters gather underneath the Guildhall to chat and watch the world go by, two little girls play around the town pump while a thirsty customer enters the Bear Inn for refreshment.

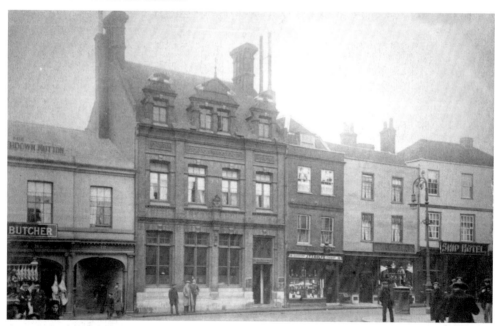

Market Place, *c.* 1916. The National Provincial Bank of England (now the Nat West) stands in the centre, with Terry's the butchers on the left. Rolfe's the chemist, River Plate Fresh Meat Ltd. and the Ship Hotel are on the right. The main entrance to the bank is on the right in this photo but it was later moved to the left of the building.

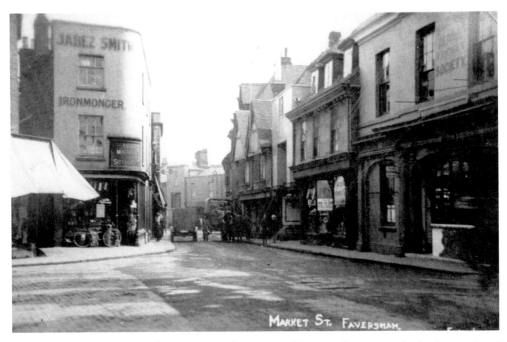

Market Street, *c.* 1918. In the centre, on the corner of Preston Street, stands the International Stores, now the Midland Bank. On the left is Jabez Smith ironmonger, with Frederick J. Terry the butcher's, Vye & Son, and William Carter, now Woolworths Stores, on the right.

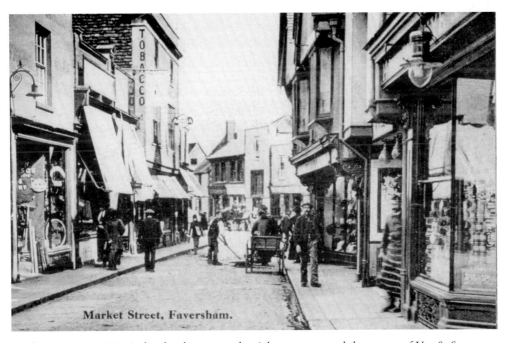

Market Street in 1906. A shy shopkeeper on the right peers around the corner of Vye & Son, now the Nationwide Building Society.

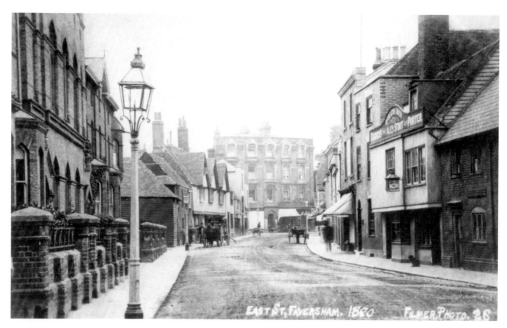

East Street, looking quiet and peaceful with only a few people about, has lost a few buildings since this picture was taken, way back in 1880. The Faversham Institute on the left, once the home of the library, was demolished and John Anderson Court built in its place. The houses, on the right of the picture opposite Newton Road, were pulled down to make way for Crescent Road.

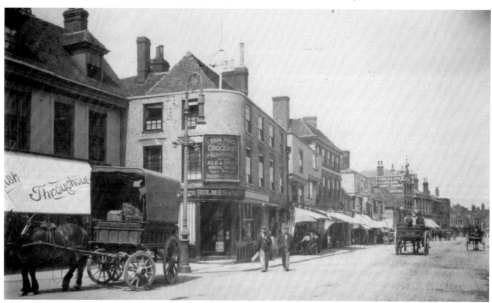

This fine photograph of Court Street, dating from the turn of the century, is taken from a glass negative. Opposite the town pump is Holmes the grocer's and further down the street is Child's department store, where customers had their money whizzed along on an overhead 'railway' to a central cash desk.

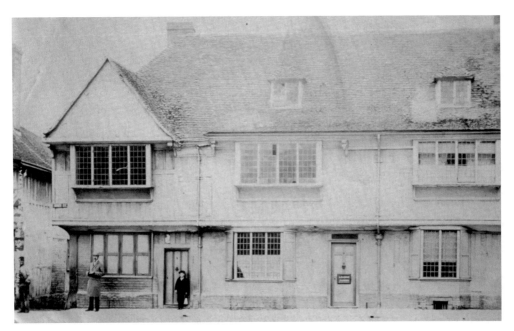

Nos 1 and 2 Abbey Street, with Quay Lane on the left of the photograph. Being just a narrow lane, it posed many traffic problems in the early 1890s. Linking the creek and its busy wharves with the town centre, it was decided in 1892 to widen Quay Lane, necessitating the demolition of these properties.

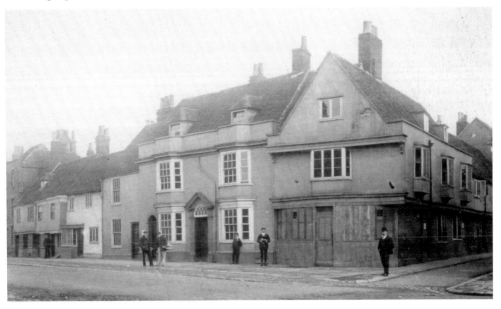

Abbey Street, *c.* 1905. As you come up Quay Lane is Church Street, which takes you to the parish church. On the left are a row of typical Abbey Street properties, which unfortunately have not survived. In their place today is a large open yard and a, now closed, building, last open as Whitbread Fremlins' social club.

Church Road, *c.* 1915. Children gather outside the police station, built in 1904, perhaps waiting for the school bell to ring. The slender church tower and spire rises majestically above the trees, which hide the District National School.

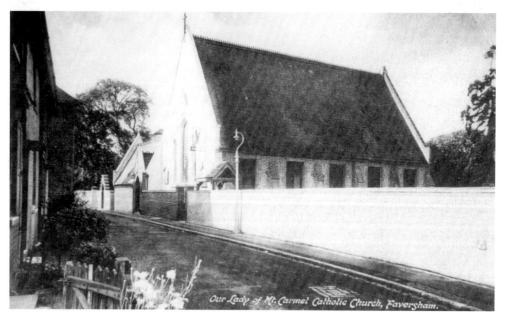

A photograph taken of Our Lady of Mount Carmel Roman Catholic church in Tanners Street a few years after it had opened in 1938. Prior to this the building had been the Empire cinema and, even earlier, a school provided by William Hall, the owner of the Faversham gunpowder factones, for the daughters of his employees.

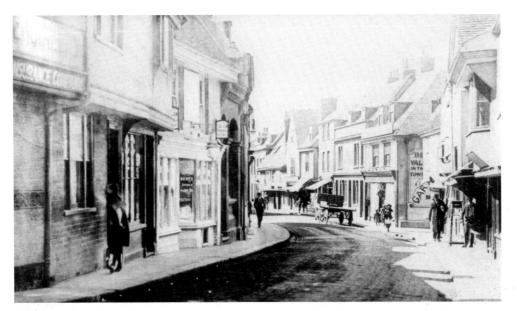

West Street, *c.* 1910. The building on the right of the picture (The People's Stores), next door to The White Horse, was demolished in 1965 to allow widening of North Lane, which enabled its alignment with South Road. Just around the corner, on the left, at the bottom of South Road is the North Kent public house, whose building now serves as a vets' surgery.

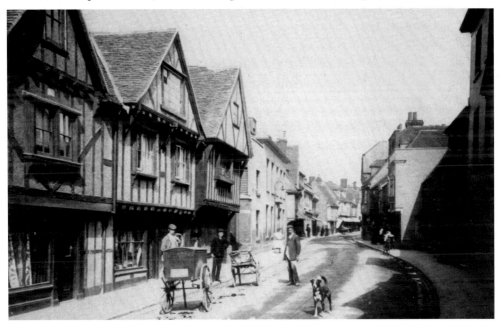

West Street looking towards The White Horse in 1906. A typical turn of the century view with tradesmen and people, plus the dog, filling the scene. These beautiful timber frame Tudor merchants' houses have sadly long since been sacrificed for the expansion to the industrial area of West Street, the site is now occupied by the Co-op supermarket.

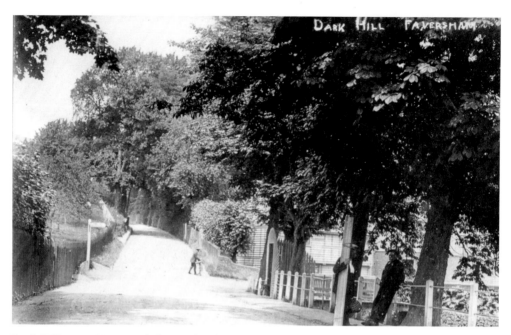

Dark Hill, *c.* 1920. Men shelter under the trees at Stonebridge Pond to escape the hot summer sun. No.1 Davington Hill Cottages, Stonebridge Pond and Davington's oldest cottage with its fake half-timbering, hides behind the large trees.

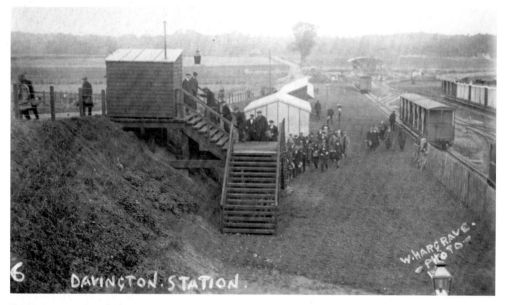

Davington station before opening on 6 October 1916. Construction workers finish their shift after a hard day's work putting the finishing touches to the railway, which opened in November 1916 to transport workers to the gunpowder factories at Uplees. An unusual feature of the railway was that many of the trains were for the sole occupancy of either men or women. The railway closed soon after the end of the First World War two years later.

SECTION TWO

Shops, Pubs and Buildings

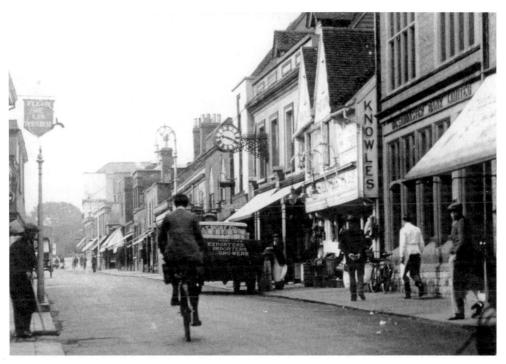

Preston Street, early one morning around 1930. The twin gables of Knowles the fruitier bring back fond memories of wonderful aromas of fresh fruit and orange boxes bought for a few pence to make rabbit hutches. The beautiful sixteenth-century building was demolished in 1965 to make way for a British Gas showroom, which is now owned by Victoria Wines Co. Ltd.

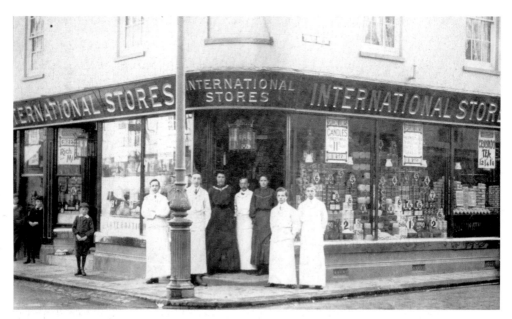

The International Stores at No. 1 Preston Street in 1906 showing well-stocked shop windows. Staff, with their clean aprons, line up outside the shop to have their photograph taken. Young lads look on, wondering what all the fuss is about. No. 1 Preston Street has had many uses since being occupied by the International Stores and the premises are now used by the Midland Bank.

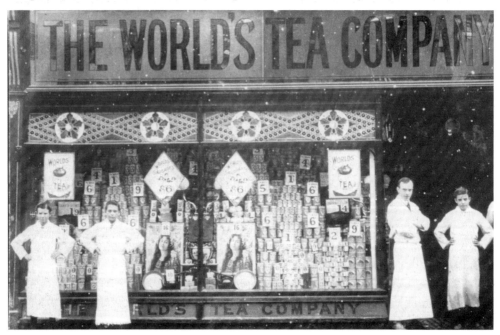

The World's Tea Company at No. 2 Preston Street, also showing a well-stocked window in 1906. With hair combed and clean aprons on, staff pose for the photographer – possibly on the same day as he took the picture above.

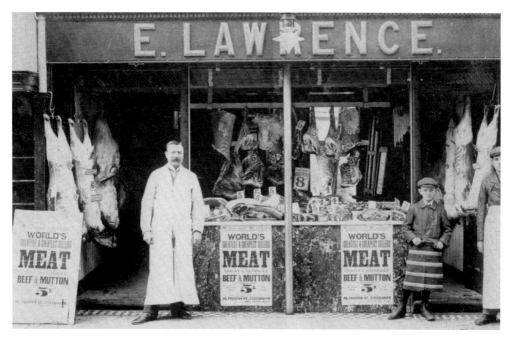

The butchers shop of E. Lawrence at No. 88 Preston Street, around the beginning of this century. The shop display of whole carcasses, hung from hooks, are ready for cutting into joints. The young lad on the right sharpens his knife, making sure the blade is keen enough to do the job. The premises at the bottom of Preston Street are now used as a jewellers.

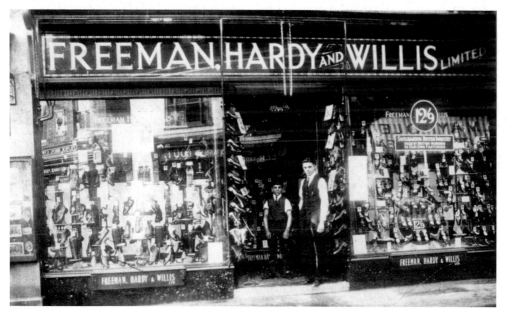

The staff of Freeman, Hardy and Willis outside their shop at No. 8 Market Street. This very popular shoe shop occupied the premises for many years, before transferring to No. 13 Market Street in the 1980s.

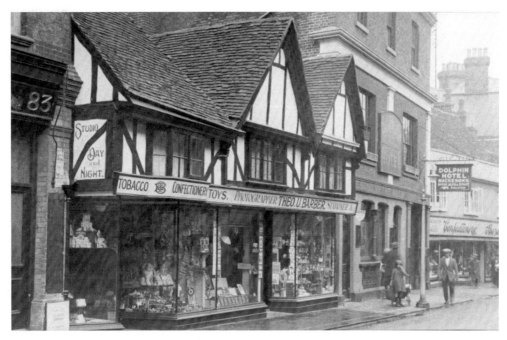

Taken in 1927, the picture shows the beautiful shop front, with its splendid timbers, of Theo U. Barber Nos 84-85 Preston Street. 'TUB' was in business as a photographer and recorded many events and street scenes as postcards which were collected and many survive today.

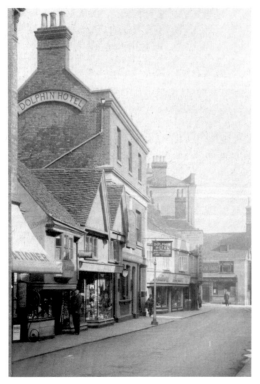

Showing Theo U. Barber's shop in Preston Street before the restoration. The Dolphin Hotel, next door, stands high and majestic against the smaller buildings of Barber and the Confectionery Bazaar. At the bottom of Preston Street, standing outside the Swan Inn, is a policeman on point duty. In the 1960s the Borough Council gave permission to pull down the Dolphin and Barber's shop, for its replacement with so-called modern premises. A Faversham guide of the 1930s quotes, 'The old Tudor House at 85, Preston Street is a good example of many of the buildings of Tudor times, small, with ceilings of low pitch and the floors below street-level'.

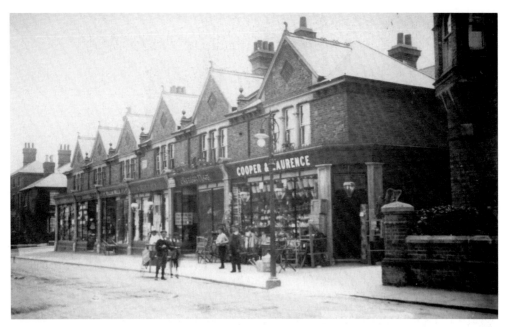

Cooper and Laurence the hardware store, with their large gas lamps, display some of their wares outside on the pavement, *c.* 1905. Children stop and stare, while the little girl on the left, because she moved during the long exposure, has almost disappeared.

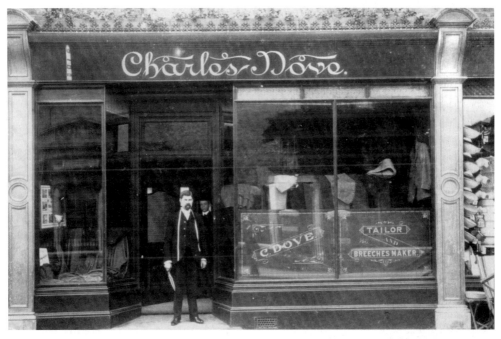

No.2 Queens Parade, *c.* 1906. Mr Charles Dove stands outside his tailors shop in East Street at the turn of the century. Tape measure at the ready and scissors in his hand he waits for a customer to enter his shop.

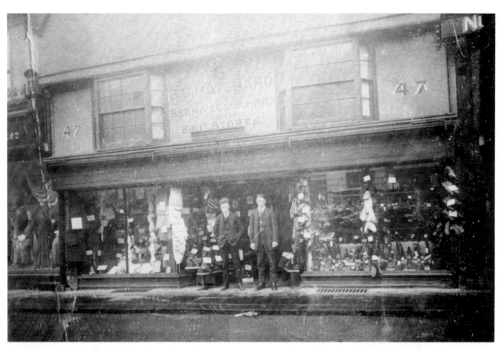

Staff of Hatchards, a much loved and sadly missed shop, outside their shop at No. 47 Court Street.

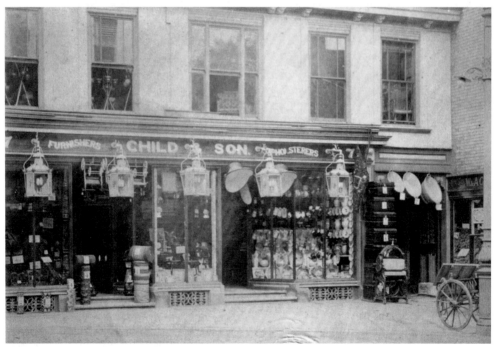

Child & Son furnishers and upholsterers at No. 7 Market Place in 1906. Shop windows display carpets, chinaware and household goods for sale, five huge gas lamps, hanging from the shop fascia, wait to illuminate their merchandise at night.

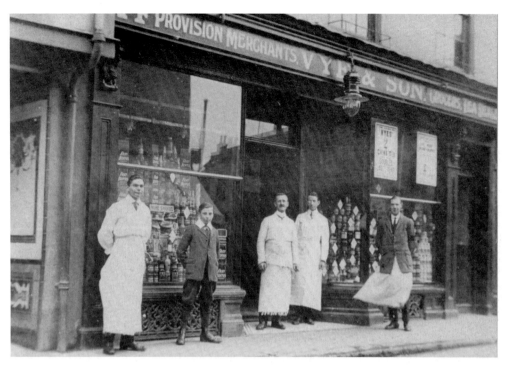

Vye & Son, the grocers at No. 14 Market Street, at the time of the First World War. Staff proudly stand outside their shop on a windy day to have their photograph taken. The shop premises are now used by the Nationwide Building Society.

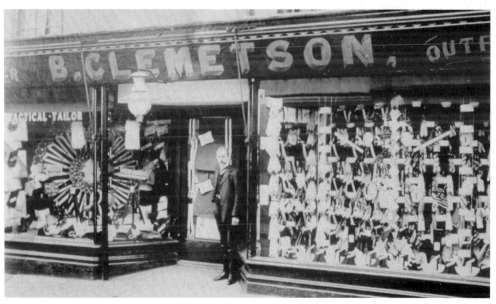

Opposite The Sun Inn in West Street, standing outside his shop at No. 115 West Street, is Mr Bertrand Clemetson, *c.* 1919. In business for many years as an outfitters, the premises are now used as a charity shop.

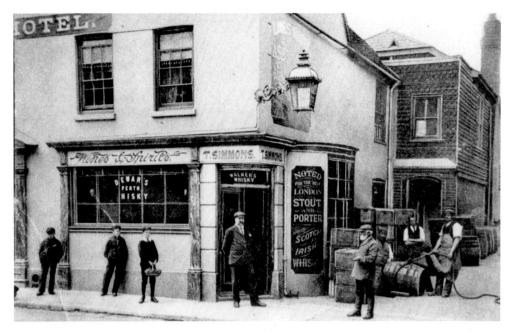

Outside the Limes Hotel, Preston Street in 1905. Two youths on the left appear to be killing time while the third, resplendent in Eton collar, is either on an errand or delivering something. The draymen delivering beer tell their own story. The very popular public house at the top of Preston Street changed its name from the Limes Hotel to the Chimney Boy in the 1970s, when an inglenook fireplace was discovered during its renovation.

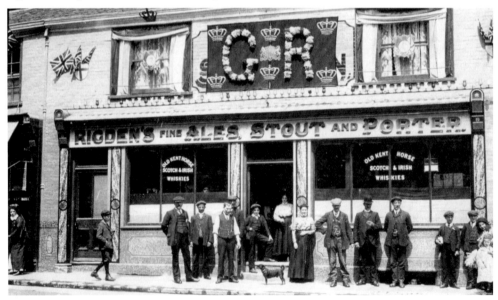

The Swan Inn at No. 6 Market Street is decorated with flags and flowers, on Thursday 22 June 1911, to celebrate the coronation of George V. William Hargrave, local photographer, has persuaded the landlord, his wife and customers to come out of the pub and pose on this joyous day.

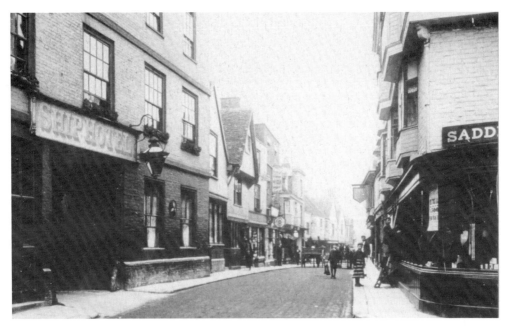

The Ship Hotel, West Street, *c.* 1913. On the corner of Market Place and West Street is Taylor's, the saddlers and harness-makers, where as a boy I bought catapult elastic for my homemade catapult – very dangerous! Further down the street on the left is Timothy White's, cash chemists, and The Sun Inn.

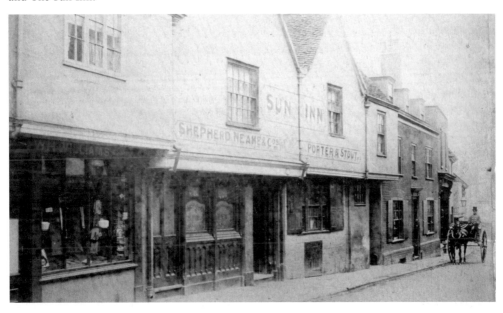

An early photograph of The Sun Inn, West Street, taken by Frederick Austin, *c.* 1900. This house was formerly the headquarters of the Porter Club, founded in 1793. The club met here for eighty years before it moved to The Ship Hotel and finally merged with a new club in Gatefield Lane. This became the Gentlemen's Club, and later the Faversham Club.

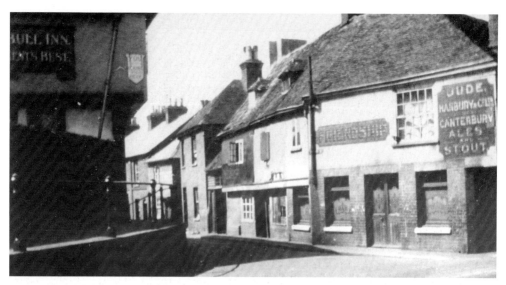

The Friendship public house at No. 64 Tanners Street, seen here on a quiet Easter Day in 1929. The Friendship was owned by an independent brewery, Jude, Handbury & Co. Ltd. and the landlord at the time was a Mr Alfred Ruffells. To the left of the photograph can be seen The Bull Inn which still stands today, while sadly the Friendship and adjacent houses were demolished in 1965 to allow for road widening.

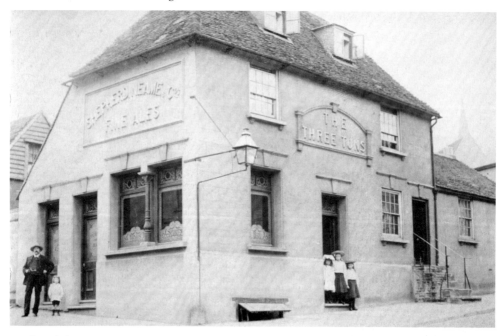

Further down Tanners Street at the bottom of Napleton Road is The Three Tuns. This public house is one of the original Shepherd Neame houses and had a very famous customer in the early 1800s, Horatio Nelson. It is said that he paid off one of his crews at the Three Tuns but the Admiral and his officers probably also signed on a few likely Faversham characters.

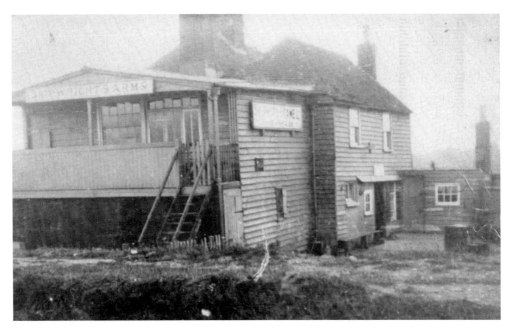

The Shipwrights Arms, Hollowshore, a pleasant wooden building with tiled roof and a verandah overlooking Faversham Creek, in 1939. Today the verandah has gone and a kitchen extension abuts the front. Once inside the pub you are greeted with a warm embrace from the large open fire – it's nice to know that some things never change.

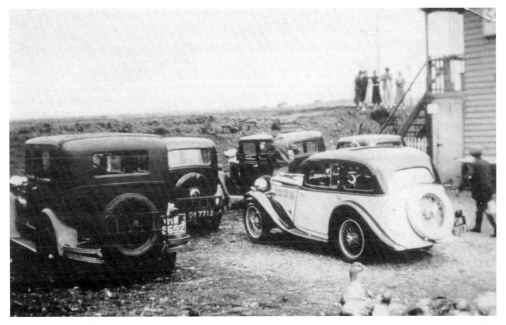

Having braved the drive across the marsh, customers drink their refreshments on the sea wall, while geese guard the cars (note the running boards!) outside the Shipwrights Arms at Hollowshore, c. 1930.

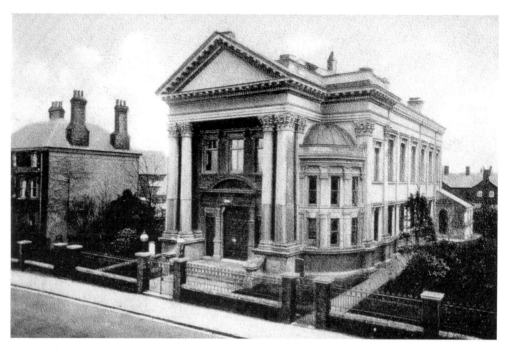

The strikingly imposing Congregational church in Newton Road, *c.* 1907. One of Faversham's architectural gems that has been lost. No longer adequately supported by its dwindling congregation, it was sold and demolished in 1975 and is now the site of Herbert Dane Court.

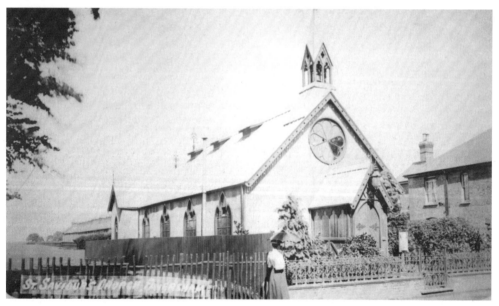

On a warm summer's morning, an Edwardian lady walks past St Saviour's church in East Street. Locally known as the Tin church, it got its unusual name from the materials used in its construction. The building has had many uses throughout its life and, although it is no longer a church, is still in use today.

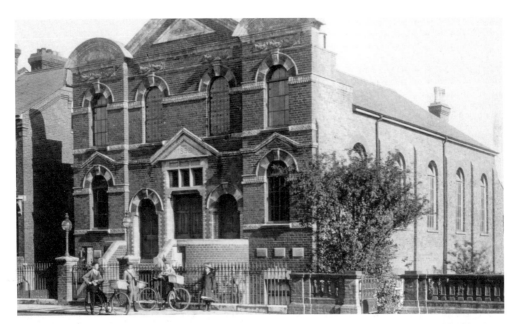

Young lads with their cycles and delivery baskets meet outside the entrance of the Bible Christian Methodist church, Stone Street, in 1905. The church was built in 1898 and stood next door to the Cottage Hospital. Having had many uses, after it ceased functioning as a place of worship, the building was eventually sold and demolished to make way for an extension to the Cottage Hospital.

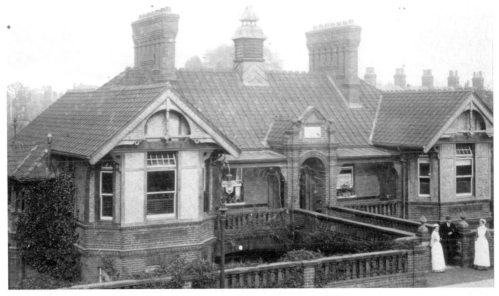

Nurses stand outside the Cottage Hospital, Stone Street, in 1908. The hospital was built on the old King's Field brickfield site which was donated by Messrs. W.E. and J. Rigden, the brewers. Mrs W.T. Townsend Hall, of Syndale Park and the widow of the late senior partner in the Gunpowder Mills at Faversham, offered £2,000 to build and furnish a hospital. The local firm of R.M. and H. Whiting built the new hospital and it was formally opened on Saturday 26 May 1888.

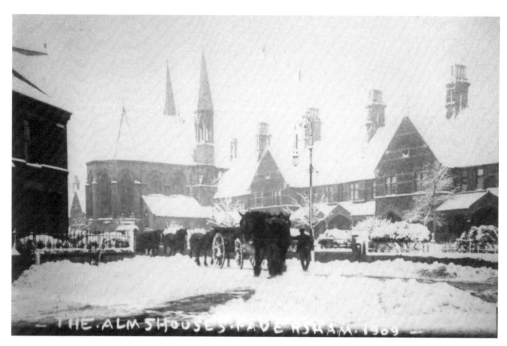

A winter's scene – wagons and horses enter Stone Street from South Road in 1909. Rising high and mighty above the horses, the snow-topped almshouses chapel, with its original spires, nestles in the centre of the 500ft-long building. This almshouse complex, completed in 1863, when it was described as a masterpiece of its kind, provided thirty homes.

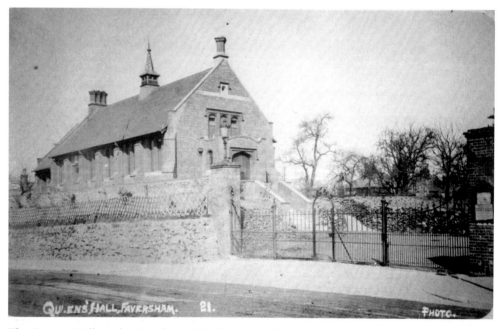

The Queen's Hall, Forbes Road, c. 1905. The beautiful iron gates have long since gone, possibly melted down for the war effort. The entrance is now used by one of the town's car parks.

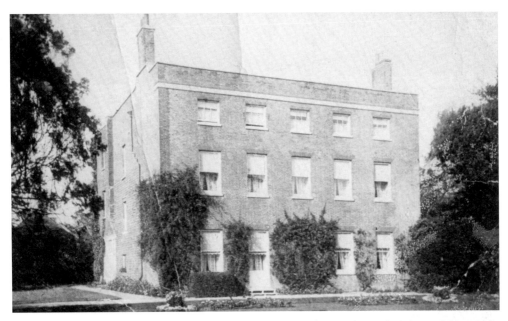

At the other end of the town, in Preston Grove, stood Preston House and its beautiful grounds. It was rather a plain, solid looking Georgian building of red brick built in 1788 by John Bax and was the home of the Hiltons, a family of bankers. Around 1908, a Mr Edward Wood lived at Preston House but it ended its days as a private nursing home before being demolished to make way for new houses in 1931.

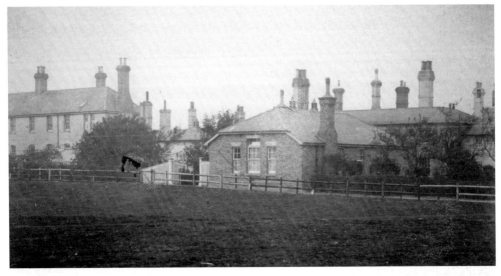

The workhouse in Lower Road, *c.* 1908, where inmates had to wear uniforms and freedom was restricted. Part of the house provided beds for tramps too on the understanding that they did some work for it. The workhouse, renamed Bensted House, became an old people's home and hospital. It eventually closed as a hospital and stood empty for many years before the building was sold and demolished for housing.

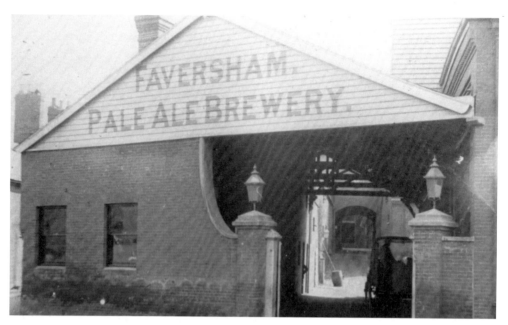

It was nearly 300 years ago – in 1698, (when the only illumination was the rushlight!) – that the Faversham Pale Ale Brewery, now known as Shepherd Neame Ltd. was first established. It has been suggested that the most probable reason for the early success of the brewing industry in Faversham was the use of the water obtained from the clear and sparkling springs which abound in the neighbourhood.

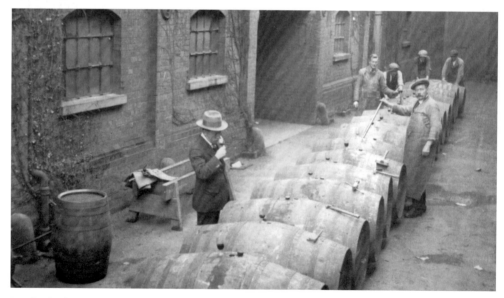

Inside the brewery, now part of the wine and spirit store, the beers are tested for quality and flavour. To this day, the characteristic flavour of Shepherd Neame's beer is maintained by the use of water of exceptional purity that is now drawn from an artesian well, 200 feet in depth, situated in the brewery premises on the site of the old pump that was used in days gone by.

SECTION THREE

Faversham Creek

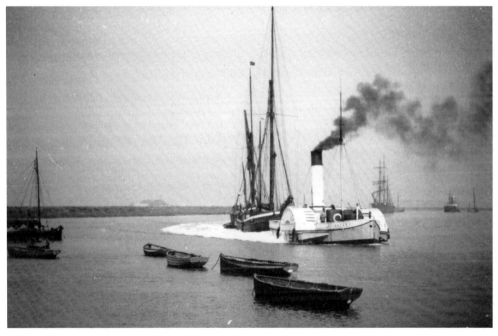

In the distance a Dutch steamer makes its way towards Faversham Creek, while a barquentine discharges its cargo of coal, *c.* 1906. The steam paddle-tug *Pioneer* enters Faversham Creek towing three barges. Passing the Shipwrights Arms on the right, the tug navigates its way up the creek to the waiting quays and wharves for unloading and loading of the barges.

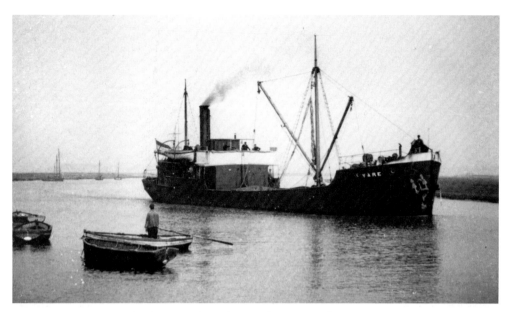

A smacksman stands in his boat watching the Dutch steamer *The Yare* entering Faversham Creek at the turn of the century. Standing on the bridge with the master, the pilot, known locally as 'hufflers' or 'hovellers', takes the wheel to navigate the creek bends.

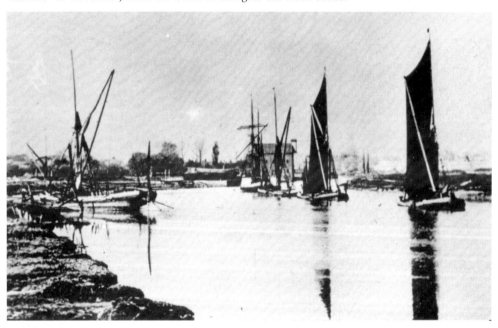

Two deep laden sailing barges wait for the steam paddle-tug *Pioneer* to take them out of Faversham Creek at the turn of the century. The year 1884 saw a huge development in the port and creek with the opening of a newly-dug channel for the upper part of the creek which eliminated a huge bend, widening and deepening the waterway, to allow vessels of 300 tons and over to reach the centre of the town for the first time.

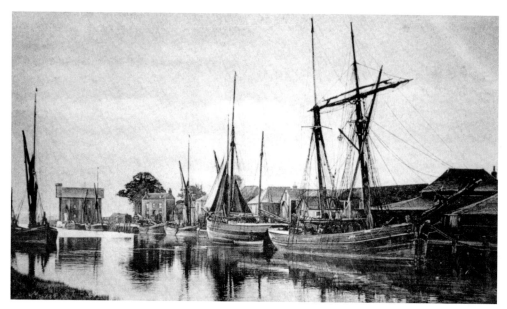

Prominent again in this picture postcard of Faversham Creek, *c.* 1904, are sailing barges. On the right is a brigantine with a cockedbilled main yard and derrick with a gin wheel for unloading and loading, behind the Baltic trading ketch second from right, are sailing barges moored at Standard Quay. Opposite, three sailing barges are moored for unloading and loading.

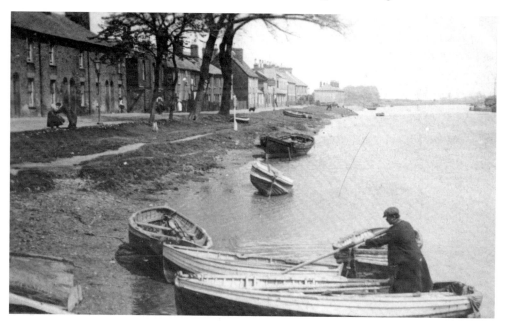

People parade along the Front Brents at high tide, while men go about their work on the creek. The Albion Tavern, half way along, waits for thirsty customers. At the end of Front Brents is Crab Island where a terrace of houses were built, these were pulled down after being marooned in the Great Flood of 1 February 1953.

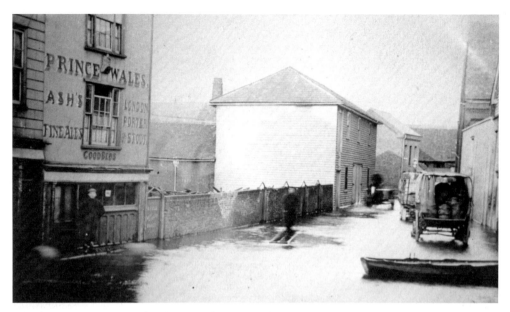

The dramatic caption on the photograph states, 'The Tidal Wave, Faversham, November 1897'. Flooding caused by abnormally high tides remains a hazard near the creek even today. The Prince of Wales, North Lane, began trading around 1850 and later changed its name to the Queen of Hearts but closed in 1960. The pub and buildings, including the stables, were demolished in 1966 for a new bottling store for Shepherd Neame's brewery.

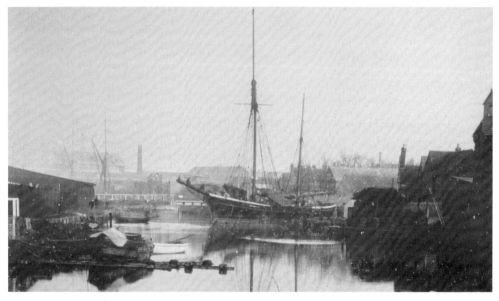

On the left, Gillett's tall warehouse can be seen in the distance rising above the two sailing barges moored alongside the wharf, stacked high with timber, c. 1908. A ketch barge, with leeboards raised, lays inside the creek basin after unloading at one of the wharves. The smaller buildings on the right were demolished in 1966 for a new bottling store for Shepherd Neame's brewery (see photograph above).

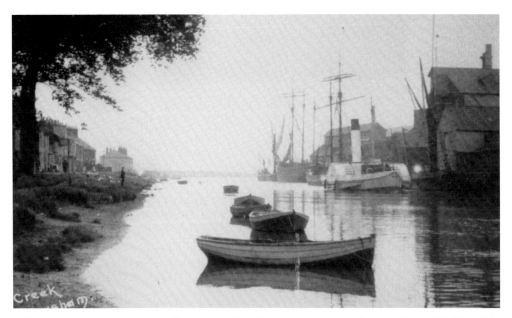

Taken from a glass negative, the photograph shows high water in Faversham Creek, *c.* 1906. Standing outside the Albion Tavern, a customer gazes across the creek at the magnificent sight of a barquentine moored alongside the crowded east bank with its works and factories. Outside Gillett's warehouse, the steam paddle-tug *Pioneer* can be seen, with its paddle boxes which prevented it going through the bridge to the Basin. It came into service in 1883 and operated until 1926 when the motor-tug *Noni* took over which in turn was succeeded by the motor-boat *Boy Mike* and then the tug *Noni II*.

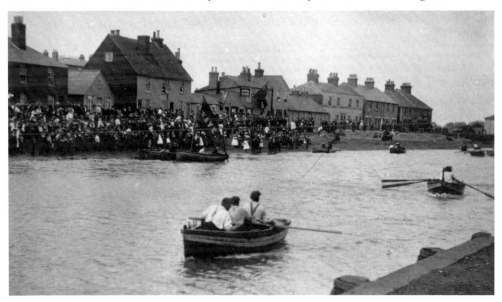

Standing outside the Albion Tavern, people line the creek banks of the Front Brents to watch and wave the first annual regatta on Faversham Creek in August 1906. Today the tradition is maintained with the annual raft race, held every summer.

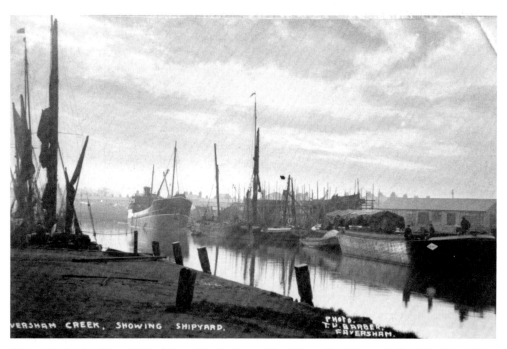

An atmospheric view of Faversham Creek shows the shipyard of James Pollock in the 1920s. Along the skyline in the distance are the Victorian terrace houses of Upper Brents, built to house brickfield and other workers. Most of the older houses were demolished in the early 1960s to make way for council houses.

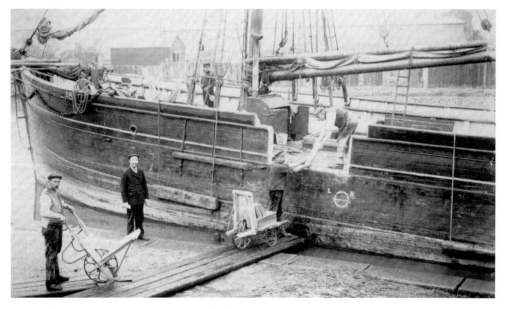

Moored opposite Upper Brents at Standard Quay, the cargo of a trading ketch, possibly slate, is unloaded by hand with the help of two crowding barrows, c. 1905. When the barrow was full the 'crowder' had to 'run like blazes' with his barrow load in order to balance it!

Shipbuilding in Faversham tended to grow with trade, although the two were not directly related. Several yards built timber vessels, notably sailing barges, in the second half of the last century, but the outstanding achievement in this field was that of James Pollock, Sons & Co. Ltd who, over a 54-year period constructed well over 1,000 craft ranging from tugs and lighters to barges, coasters and a whole range of port-service and specialised craft.

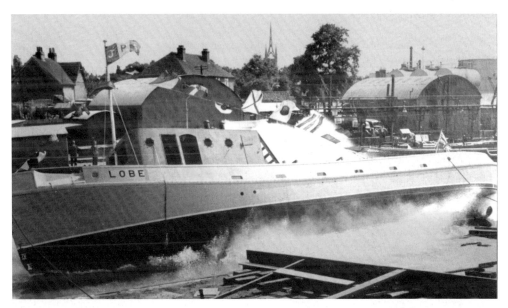

Rising above the trees, the parish church spire looks out across Faversham Creek to witness another sideways launch, necessitated by the narrowness of the waterway. The motor-tug *Lobe*, built by James Pollock's shipyard, enters the creek on 27 June 1952. After the launch, a wave would soak unsuspecting spectators on the opposite bank.

47

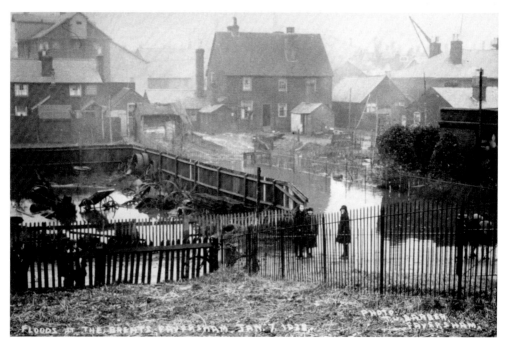

Entitled, 'Floods at the Brents, Faversham', Theo Barber took this photograph from the bank opposite T. Seager's iron foundry, on 7 January 1928. The tall Gillett's warehouse towers above the Albion Tavern on the left. The properties to the right were demolished many years later, hence the gaps on the Front Brents.

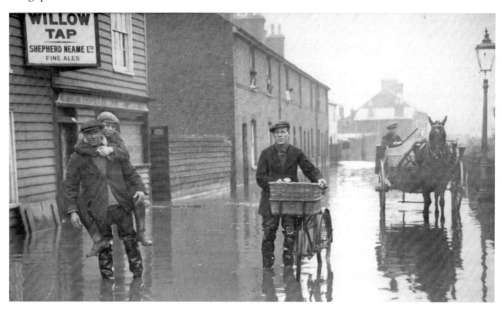

Theo Barber might have got his feet wet for this photograph of the flood. People escape upstairs and look out of their windows in Church Road at the deluge. A lucky boy outside the Willow Tap keeps his feet dry with a piggyback through the water.

SECTION FOUR

Transport

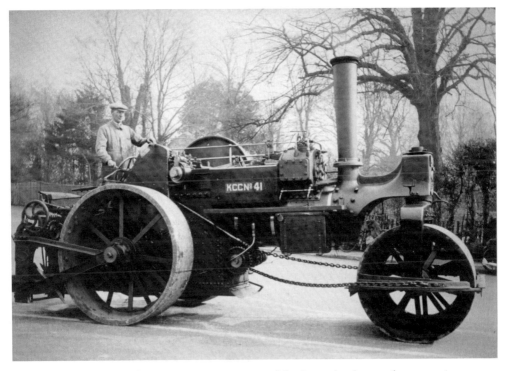

As well as its agricultural use, steam power was used for heavy haulage and construction, as shown by this Kent County Council steam-roller, c. 1930.

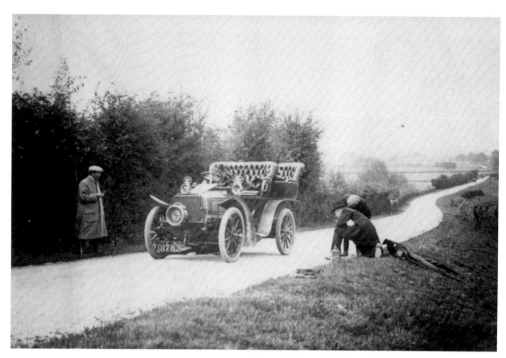

A quiet drive in the Faversham countryside on 17 May 1906 hits a problem – the new motor car has broken down! The passengers, including a photographer, look for the problem, while the driver has gone for help.

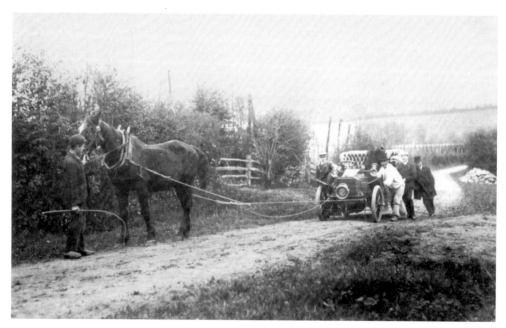

Help has arrived in the shape of a horse – good old fashioned horse power! It makes for a rather undignified end to their excursion as the horse and passengers tow the car to a garage.

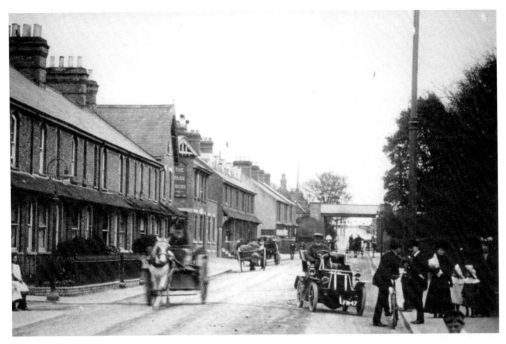

A busy Whitstable Road in the early 1900s. The railway bridge across the road carried the branch line to the creek and this extended along Standard Quay to a stub terminal at the foot of Stockwell Lane. The closing of the branch line made the bridge redundant and subsequently it was demolished, enabling the height restriction in Whitstable Road to be lifted.

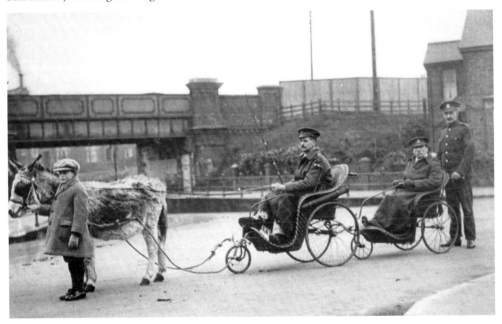

Neddy does his bit – 3 February 1916. A boy and a donkey lead an odd procession in Forbes Road, as two convalescing soldiers are pulled along in their bath-chairs.

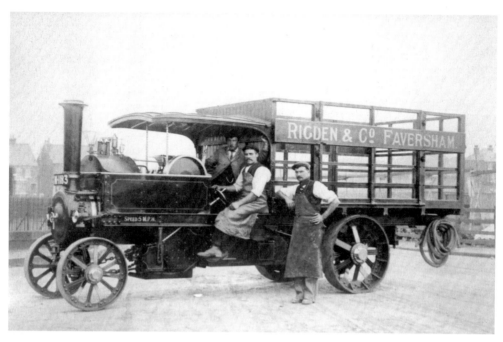

An early delivery wagon (Foden No. 1118), owned by Rigden & Co., in Faversham when new in June 1906. The well proportioned vehicle looks racy in appearance, but this is belied by the inscription on the side of the engine stating that its speed was limited to 5 mph.

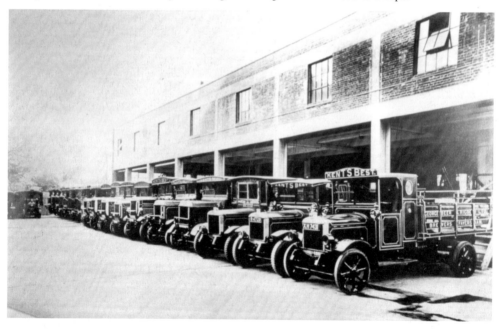

In 1922 Rigden's amalgamated with George Beer of the Star Brewery in Broad Street, Canterbury, the firm being known thereafter as George Beer & Rigden. The neatly parked fleet of delivery vehicles are ready to deliver the beer from the Faversham brewery, *c.* 1930.

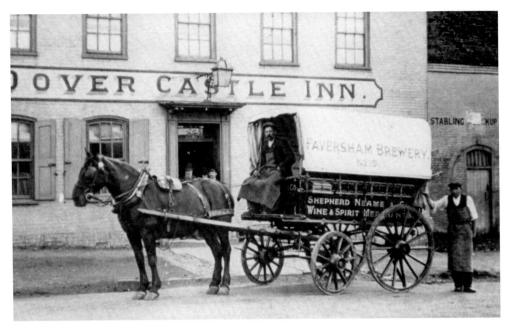

Standing outside the Dover Castle Inn, Greenstreet, Teynham in 1903, a beautifully signcovered dray from the Faversham brewery of Shepherd Neame & Co.

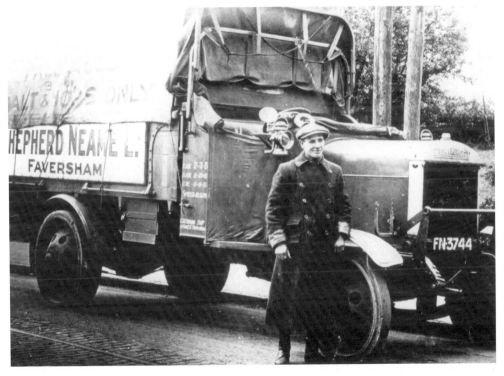

Shepherd Neame had both horse-drawn drays and petrol-engined lorries. Standing proudly beside his solid-tyred Thorneycroft lorry (speed 12 mph) on 10 May 1920 is All Culver.

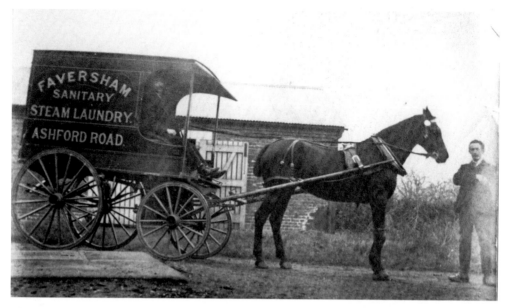

The Faversham Sanitary Steam Laundry was established by a locally formed company in 1897 on the Ashford Road. The photograph shows one of their early horse-drawn delivery wagons at the turn of the century. The laundry has been modernised over the years and still operates from its original premises just off the A2.

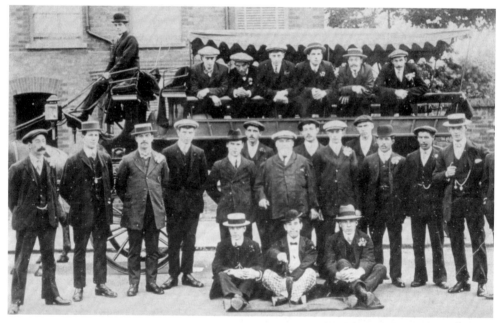

A horse-drawn wagonette taking smartly dressed gentlemen on a firm's outing, c. 1910. Note the assortment of head attire and the man sitting in front with his little umbrella. The hills around Faversham sometimes caused problems so, to help the horses, passengers would be requested to alight and push from behind when coming to a steep hill.

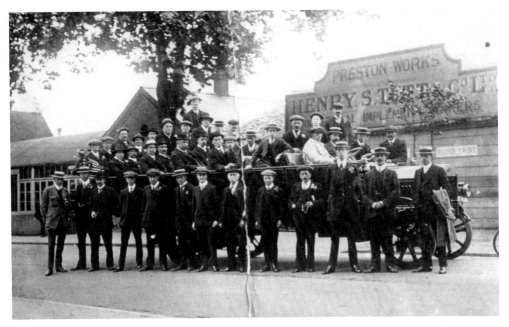

A charabanc works' outing for staff of agricultural merchants Henry Tett at which the men, in their best outfits and many sporting straw boaters, line up in The Mall to have their photograph taken on 12 July 1913.

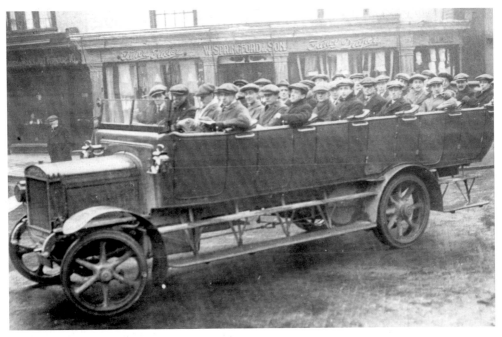

A typical special event postcard was the charabanc outing. Perhaps only fifty or so cards would be printed, as only those on the outing would be interested in buying the picture. This one shows an early Dennis charabanc in Market Place on 22 February 1915.

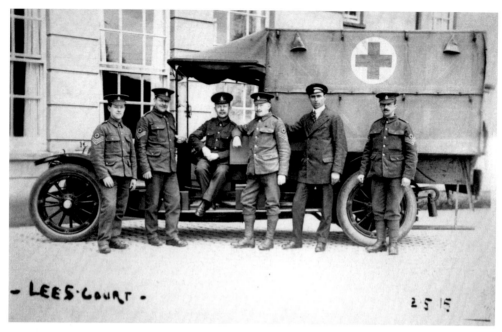

Lees Court. As with many other large houses in the area, accommodation was given over for the convalescence of casualties who returned from the front in the First World War. This group from the Medical Corps line up alongside their ambulance vehicle for Mr Hargrave's camera on 2 May 1915.

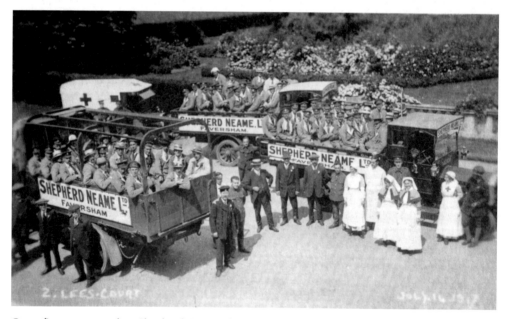

On a fine summers day, Shepherd Neame have generously loaned their fleet of lorries to take soldiers and staff of the First World War, stationed at Lees Court, on a day trip to Herne Bay on 14 July 1917.

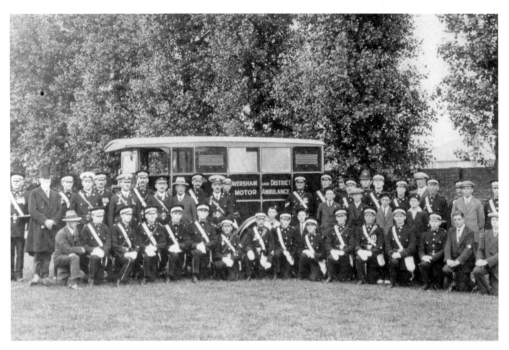

Members of the Faversham and District Motor Ambulance line up to have their picture taken with their new ambulance, *c.* 1920.

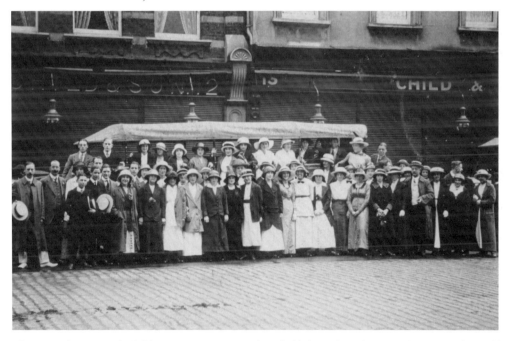

The annual outing of Child's, Court Street, on their half-day, Thursday 16 July 1914. The staff have their picture taken alongside their charabanc and are ready to go. Mr Child and his family always joined them for these occasions.

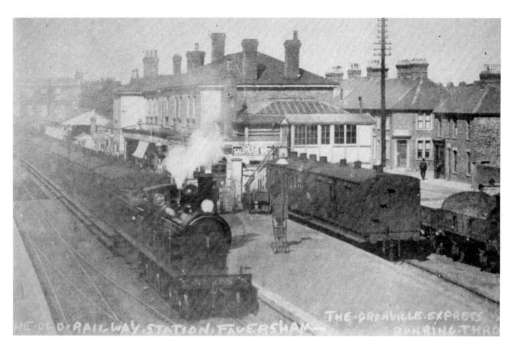

The old railway station, Faversham, which was directly opposite Newton Road, shows the Granville Express, which was named after the large hotel adjacent to Ramsgate Harbour. The present railway station was built in 1897.

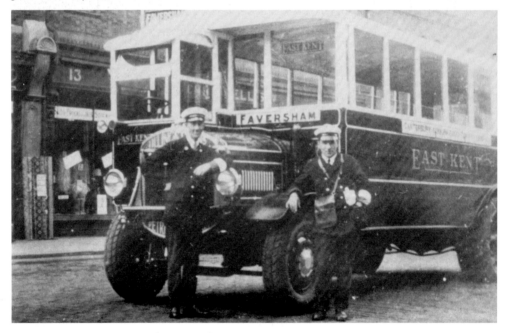

A single-deck Tilling Stevens petrol-electric bus, owned by the East Kent Road Car Company, with its proud driver (on the left) and conductor, stands in Court Street opposite the former Harry Child's drapery store, c. 1930. The shop is now part of the Shepherd Neame brewery complex.

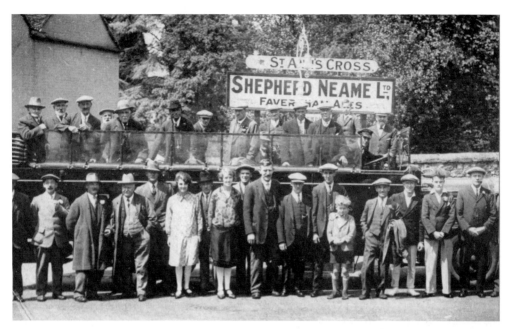

A charabanc outing, *c.* 1920, from St Ann's Cross public house in South Road.

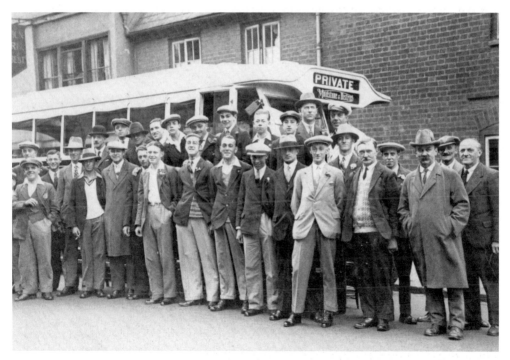

Outings from public houses were extremely popular before and after the Second World War and this photograph, *c.* 1938, shows one from the Recreation Tavern in East Street. The pub closed its doors in 1961 and lay empty till 1974, when it was converted into a restaurant-bar. The building is now used as an Indian restaurant.

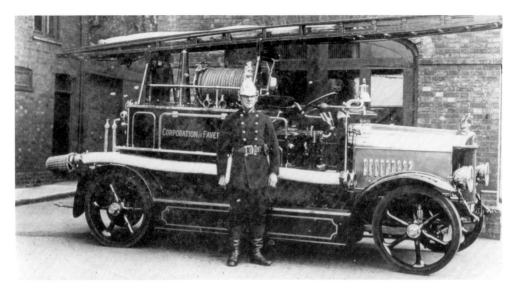

A fireman stands proudly beside his new petrol fire engine delivered in 1926. Behind the fire engine, in Court Street, is Faversham's first purpose-built fire station, one of the oldest of its kind to survive. Today it is used as a charity shop.

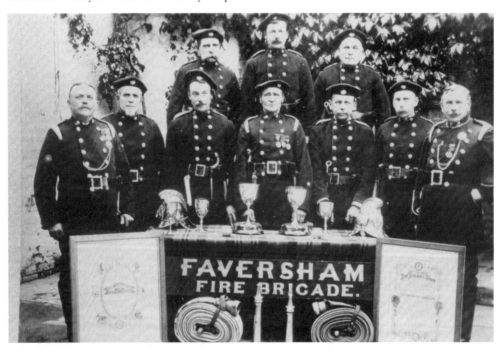

The first municipal fire brigade, manned by volunteers, was not formed until 1873. The first local fire brigades were provided, as in many other towns, by insurance companies, such as the Norwich Union and Kent, to protect policyholders' properties. Faversham's firemen had a successful competition against other fire brigades, winning many trophies and diplomas around 1905. Their banner states 'The National Fire Brigade Union, Fire Tournament and Competitions'.

Events and Celebrations

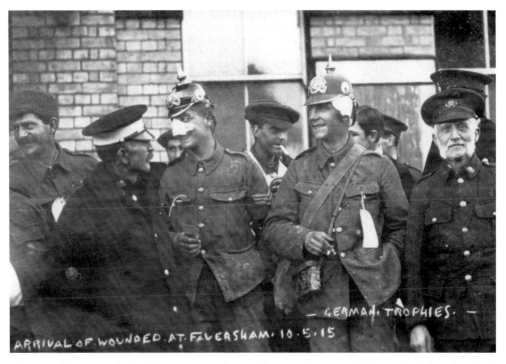

The arrival of wounded soldiers at Faversham railway station on 10 May 1915. Sporting their German trophies, the famous picklehaube officers' helmets, the men are laughing and chatting as they wait, presumably for transport to the Mount military hospital at Faversham. Their uniforms are still spattered with mud from the fields of France or Belgium and their faces betray a range of emotions.

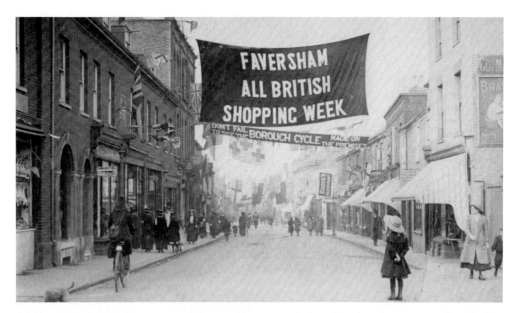

An enormous banner strung across Preston Street proclaims that the picture was taken during Faversham all-British shopping week in March 1911. Shopkeepers clearly entered into the spirit of the event, with Union Jacks flying along the length of the street. Another banner tells shoppers, 'Don't fail to see the Borough cycle, made on the premises.'

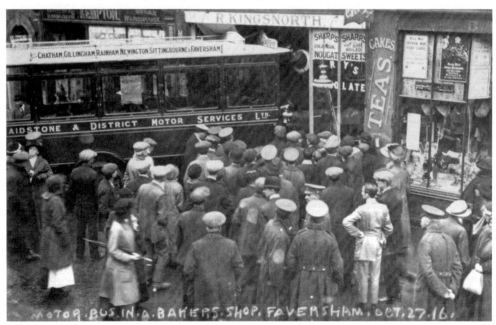

Shoppers had a lucky escape when a runaway bus ploughed into Kingsnorth the bakers on 27 October 1916. The bus was travelling along Preston Street when the steering locked. Fortunately, the bus was empty because it had only just left the garage opposite. The two shop assistants were not so lucky. They were unable to escape and were pinned by the counters, which had been pushed back by the bus.

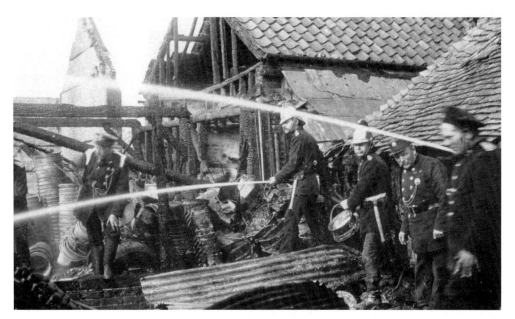

A group of Faversham fire fighters at the Big Fire at Faversham, which started in the early hours of the morning of Thursday 28 May 1908. The blaze stretched from behind the premises fronting Market Street on the south to the rear of the Dolphin Hotel in Preston Street.

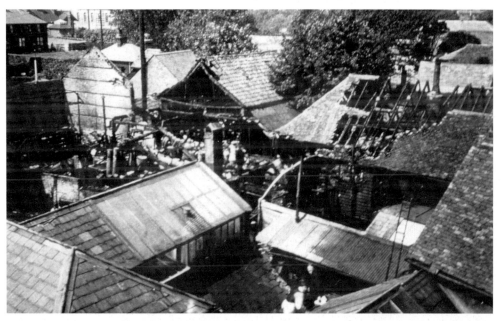

The scene after the fire (see above) illustrates the extensive damage to the buildings. The fire spread behind Preston Street as far as the Dolphin Hotel where the scullery and harness room were burned. Behind the corner of the street, the printing works of Messrs Voile and Roberson suffered damage and a Corporation cottage was burned. The premises most severely damaged were those of Henry S. Tett and J. H. Curling.

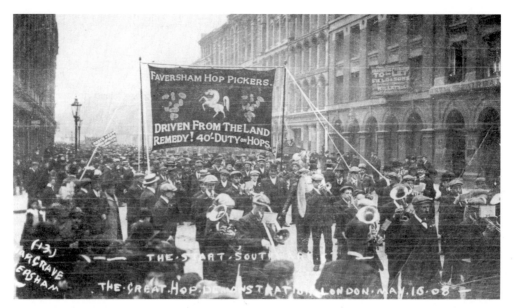

Faversham hop pickers are pictured at the start of a demonstration march at Southwark on 16 May 1908. They claimed they were being driven from the land. The remedy, they said, was the imposition of a forty shilling duty per hundredweight on imported hops. There were huge demonstrations in London and Kent protesting at the bulk importation.

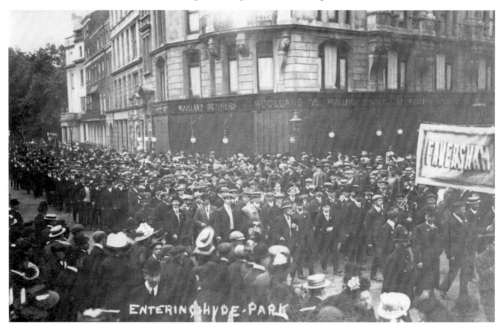

The protesters from Faversham are seen entering Hyde Park while taking part in the 'great Licensing Bill demonstration' of 27 September 1908. The House of Lords defeated the changes to the licensing laws at that time. They were finally changed during the First World War as a means of keeping munitions workers out of the pub during working hours.

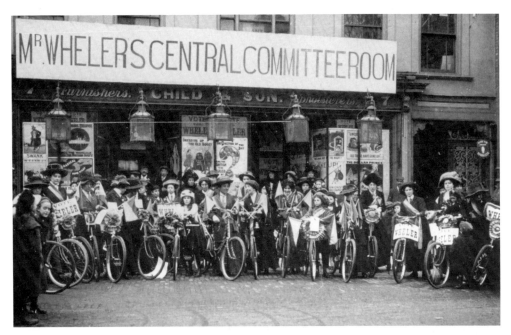

Mr Granville Wheler's central committee room above the shop of Child & Son, 7 Market Place, shows windows filled with posters of issues of the day for the 1910 General Election. A party of lady cyclists, their machines decorated with Conservative colours and some sporting flags, prepare to parade up Court Street.

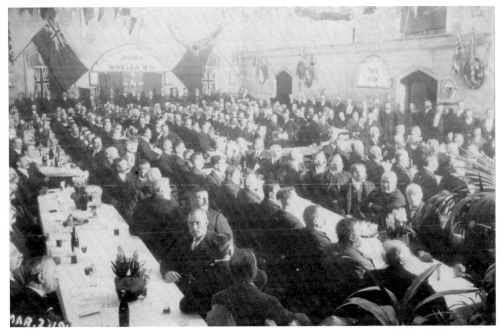

A dinner was held in the lecture hall in East Street on 2 March 1910 to celebrate Mr Granville Wheler's return to Parliament with a majority of 2,044.

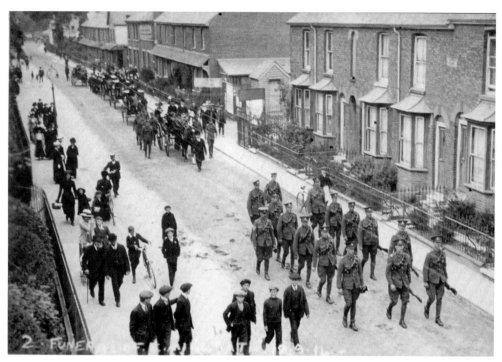

A military funeral winding its way along Whitstable Road to the cemetery on 19 September 1914. The deceased must have been a soldier of high rank or someone who was very well known in the town.

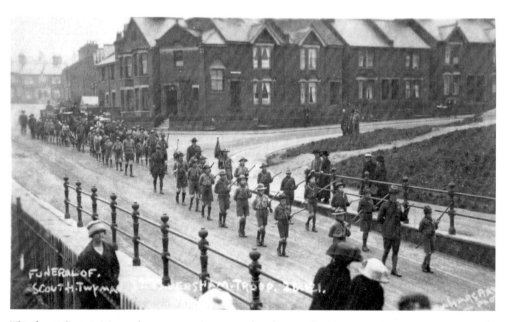

The funeral procession of scout, H. Twyman of 3rd Faversham troop proceeding along Forbes Road to the cemetery in Love Lane on 26 January 1921.

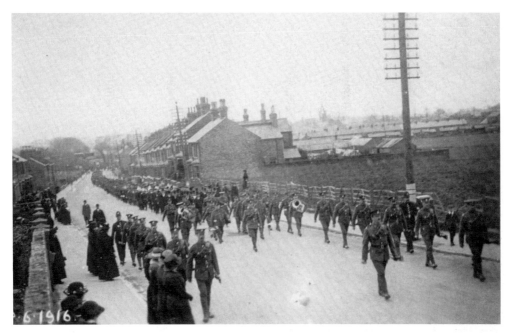

In the cemetery in Love Lane at Faversham stands a very large Maltese Cross. It marks the mass grave of the victims of an ammunition explosion that took place on Sunday 2 April 1916 about three miles north of the town at Uplees Marsh. The photograph shows the funeral procession of those killed in the explosion, making its way up Whitstable Road to the cemetery on 6 April 1916.

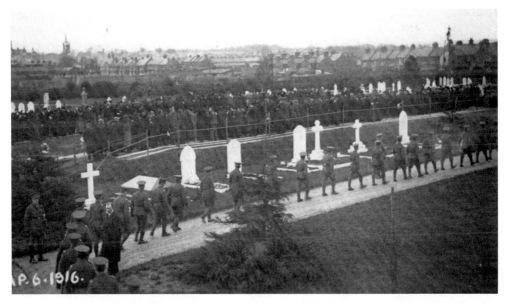

In the distance the parish church, rising above the skyline like an angel, looks down upon the funeral procession of the Great Explosion entering Faversham cemetery on 6 April 1916. Many hundreds of mourners lined the mass grave at the cemetery as the burial service was read by the Archbishop of Canterbury, Dr Randell Davidson.

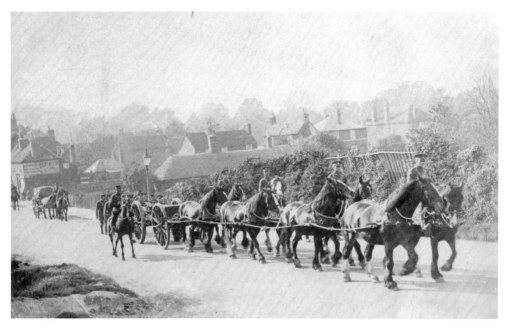

The horse-drawn guns must have been a familiar sight in the Faversham area just before the First World War, when this picture was taken. Although dressed in drab khaki the military splendour of the gun team is revealed as the heavy horses pull the field-gun along the otherwise empty Canterbury Road. The Windmill pub, Preston, can be seen on the left of the picture.

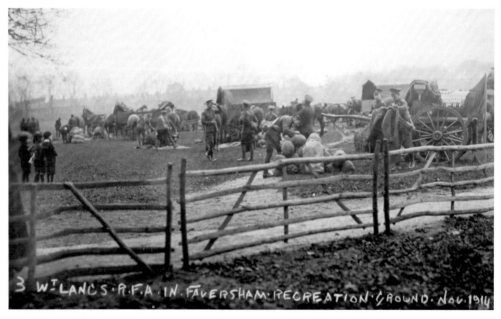

Faversham recreation ground was used as a temporary camp when the West Lancs Royal Field Artillery arrived in November 1914 (note the kitbags in the centre). They were watched at the top of the rec, near the lodge, by a group of fascinated young boys.

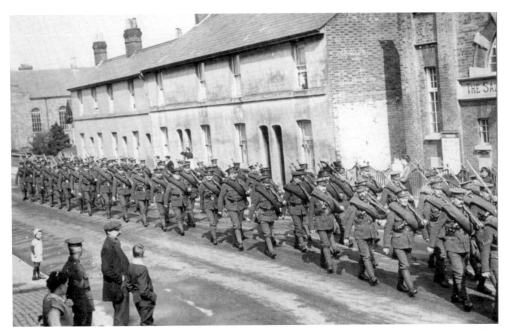

The National Guard on the march in Stone Street in April 1915. The men were the 'old 'uns' like the Home Guard in the Second World War, but some went to the front when losses became overwhelming. The leading group is passing the Salvation Army citadel, now used by the Allegro School of Dancing.

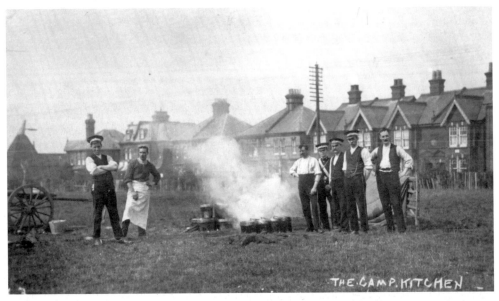

Ambulance Field Day, Easter 1914. The camp kitchen put up at the southern end of the field facing the oast house of Perry Court Farm. That Easter Monday was nothing less than a full dress rehearsal of methods of rescue and medical treatment of the wounded in time of conflict. The need for such exercises seemed increasingly important as the threat of war loomed closer.

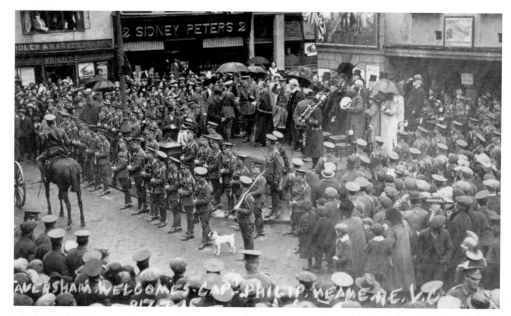

Faversham welcomes Captain Philip Neame V.C. on Saturday 17 July 1915. The scene, in Faversham Market Place, shows leading representatives of the borough and county, including: Lord Harris, Deputy Lieutenant; the Mayor, Dr S.R. Alexander; the Town Clerk, Guy Tassell; and the Mace-bearer, Mr W.H. Smith, bearing the two historic maces.

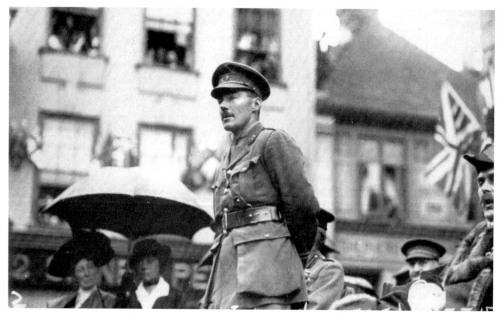

'Hip! Hip! Hooray!' roared the Faversham crowds as they welcomed their special hero back to his home town on that Saturday 17 July 1915 with a civic reception. Captain Philip Neame (one of the best-known names in the county) had become one of the first men to win the Victoria Cross for valour in the First World War.

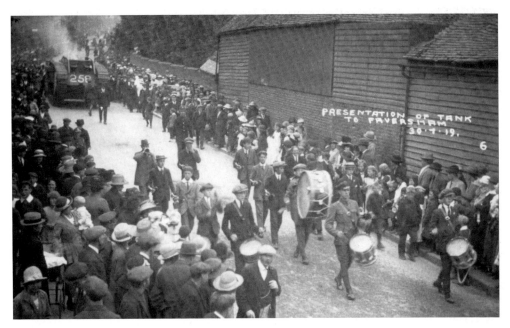

The Faversham tank No. 258, having left the railway depot in Station Road, heads down Newton Road under its own power to its final resting place on the specially-prepared platform at the north west corner of the recreation ground on 30 July 1919.

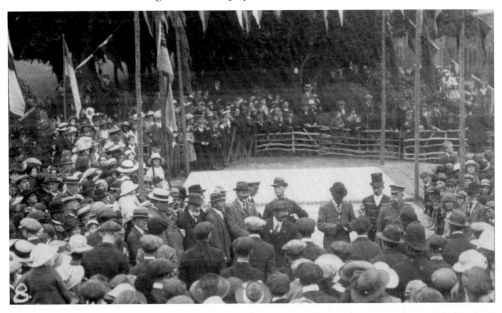

Awaiting the arrival of the tank in the recreation ground on 30 July 1919. Along the whole of the route – Station Road, down Newton Road with its hundreds of school children waving and cheering, and along East Street – it was preceded by the band of the local branch of the National Federation of Discharged and Demobilised Sailors and Soldiers and escorted by members of the Federation under the command of Charles Kennett (no relation to the author).

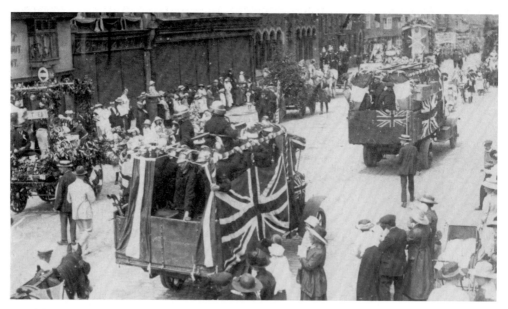

Fixed by the Government as Peace Celebration Day, Faversham showed its joy on Saturday 19 July 1919, with church bells ringing out at intervals, streets were decorated with flags, various bands in the recreation ground and a pageant processed from Newton Road. Spectators wore their Sunday best, with the women sporting their summer hats, watching the pageant passing Child's in Court Street, which is now Shepherd Neame offices.

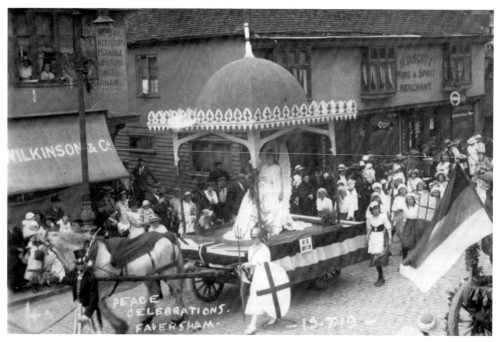

Peace Celebration Day, 19 July 1919. A crowded Court Street as the procession passes Partridge Lane on its way to the Guildhall in Market Place.

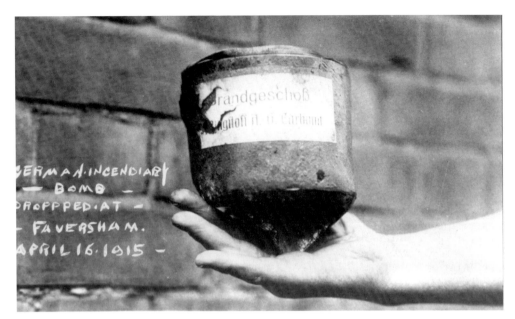

The damage caused by German incendiary bomb, dropped at Faversham, 16 April 1915. Five bombs were dropped in the Faversham area on that day: one fell near the main London railway at the Mount cricket ground, a second in the Ashford Road a few hundred yards south of its junction with the London Road, and a third in a market garden at the back of the old engine depot in Preston village. A fourth fell among fruit trees at Macknade Farm and a fifth in hop gardens at Colkins.

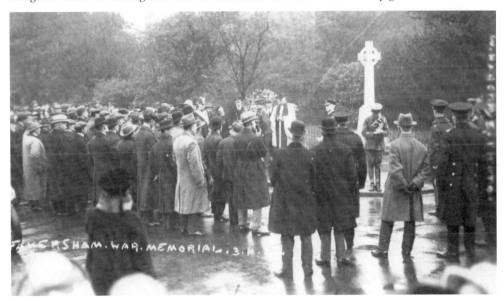

In 1922 a wing was added to the Cottage Hospital which provided six additional beds. In the same year the memorial cross in the garden opposite was erected. The hospital extension and the cross were memorials of the First World War and were opened and unveiled on 3 November 1922, by Admiral Sir Hugh Evans Thomas, K.C.B, K.C.M.G., C.B.

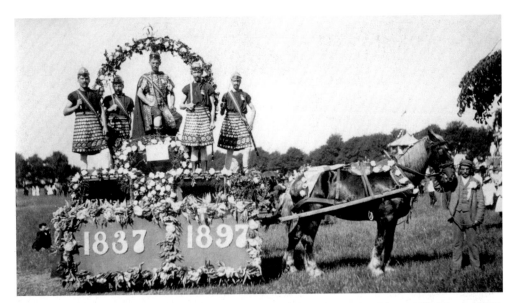

Patriotism was the keyword when Faversham celebrated Queen Victoria's Diamond Jubilee in 1897. A carnival parade was held on 22 June, with colourful floats depicting a wide variety of tableaux, Roman and empirical. The intricately flower-decorated floats were judged in the Faversham recreation ground, which then had a bandstand, and there was no shortage of farm carts and horses.

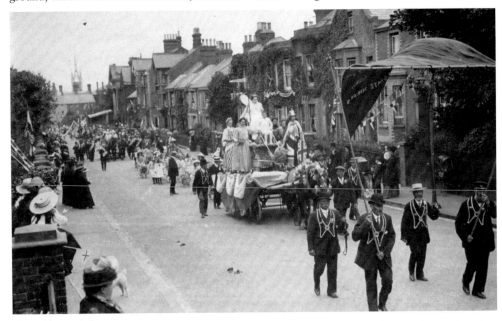

Coronation Day. King George V was crowned on 22 June 1911. Faversham celebrated with a floral procession, said to be the longest in the town's history which started from St John's Road, went as far west as South Road via Preston Street and ended in the recreation ground where there was a great battle of flowers and confetti. The picture shows the carnival making its way up Newton Road on its journey through the town.

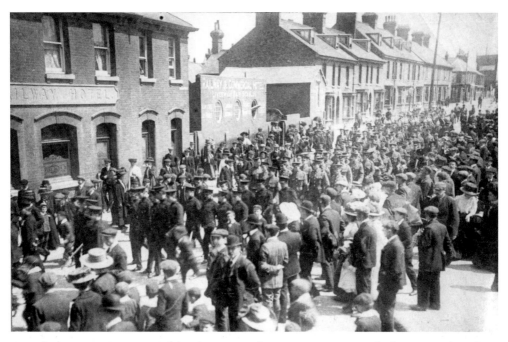

Crowds thronging Station Road for the memorial service procession to the late King Edward VII on 20 May 1910.

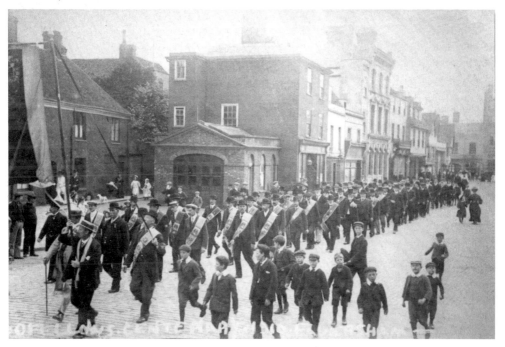

Watched by young lads, The Oddfellows, with their sashes and assortment of head attire, celebrate their centenary in 1910 with a parade through the town centre. The picture shows the procession passing the fire station in Court Street.

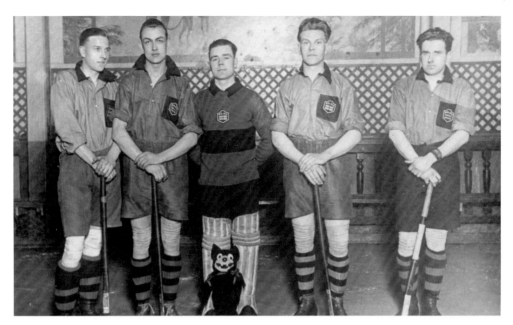

The town's rink hockey – now known as roller hockey – teams dominated both national and international tournaments in the 1920s. Their success peaked in 1930 when a side won the Cup of Nations against five other international teams at a tournament at Montreux, Switzerland. The photograph shows Faversham's famous rink hockey team – world beaters for England in 1930. Left to right: Perce Monk, C.H. ('Cush') Moon (captain), Bert Boorman (goalkeeper), Jack Cornford, Fred Curry and 'Felix' the black cat mascot.

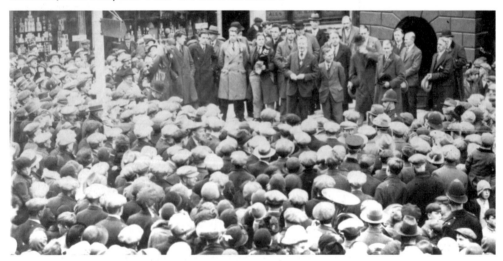

The Faversham players sailed from Calais to Dover with the Australian cricket team and on their arrival at Faversham they were met by hundreds crowding Station Road. Headed by the Gospel Mission brass band, the men were towed in a decorated car through be-flagged streets, with Moon holding the cup on top of the car. At a civic reception in Market Place the Mayor, Councillor J.H. Johnson, members of the Corporation and Guy Tassell, Town Clerk, welcomed and congratulated them.

SECTION SIX

Sport and Leisure

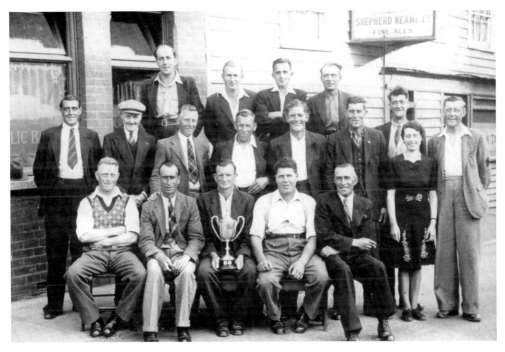

Regulars of the Willow Tap public house, including members of the cup-winning darts team, *c.* 1948. Back row, left to right: T. Stokes, N. Gregory, B. French, P. Hills. Middle row: C. Beer, G. Payne, C. Lennard, H. Lennard, H. Hyland, W. Hyland, A. Ramsden, Mrs Groom (landlady), R. Ramsden. Front row: J. Groom (landlord), W. Carter, H. Card, C. Hyland, F. Jordan.

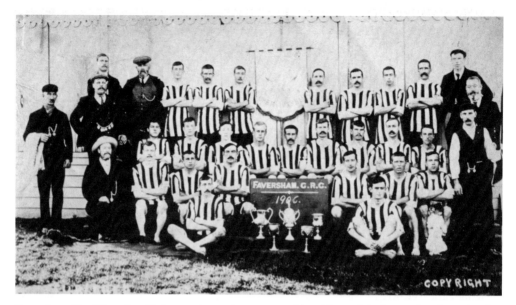

Faversham Goal-Running Club seated round an array of trophies and in front of a championship bannerette won at the Faversham and district goal-running competition held in the Faversham football ground on Saturday 7 July 1906, against teams from Whitstable, Waltham, Teynham and Sittingbourne. The bannerette and prizes were distributed by the Mayor of Faversham, Mr E. Chambers.

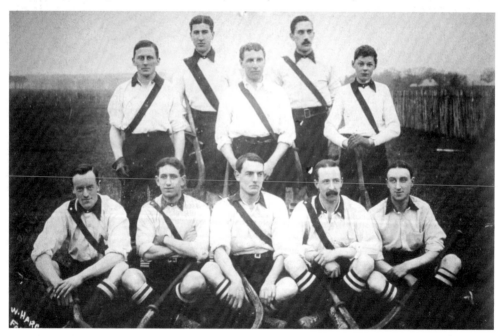

Members of the Faversham hockey team for the 1906-1907 season. Faversham (Gents) Hockey Club's playing ground was at Perry Court Meadow and their colours were blue and white. Their officers included, Mr W.B. Holmes (captain) and Mr J. Jackman (vice-captain). Grosvenor Hockey Club (Ladies) shared the Perry Court Meadow ground and their colours were light and dark blue.

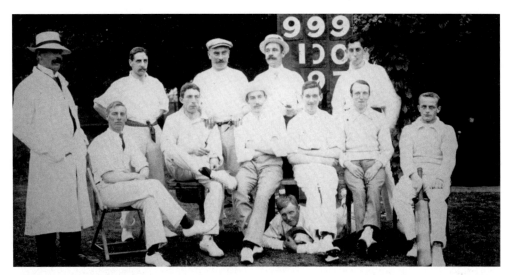

A cricket match at Belmont, August 1907. George Robert Canning Harris, 4th Lord Harris, of Belmont Park, Throwley, Faversham, described as a 'true English gentleman', was one of the most highly respected personalities in the game of cricket at county and national level. A gifted player who not only became captain of the county side in 1875 but also captained England on four occasions, 1878/79, 1880 and twice in 1884.

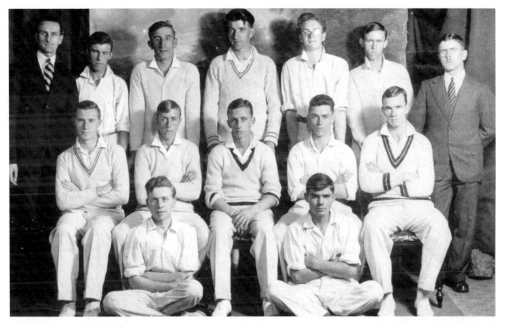

Davington Priory cricket team in 1930. The club was started about a year before this picture was taken. The team practiced on Sid Bones's farm – now Reedland Crescent playing field – before turfing cattle from a field beyond the boundary of the town to create the present Davington pitch in 1939. The Davington team featured seven Jacobs brothers – Ron, Eric, Harold, Reg, Les, Cliff and Sid. When one spoke of Davington Cricket Club it was the brothers who sprang to mind.

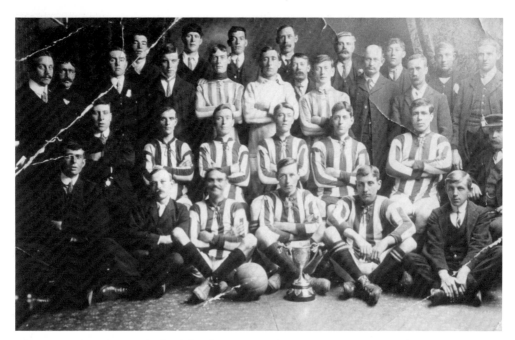

The Cotton Powder Football Club of 1910-11, who were runners-up in the Faversham and District League. They all sport shirts with lace-up collars, which have recently returned to fashion on the soccer field. The ball is also laced, and looks ten times heavier than today's footballs.

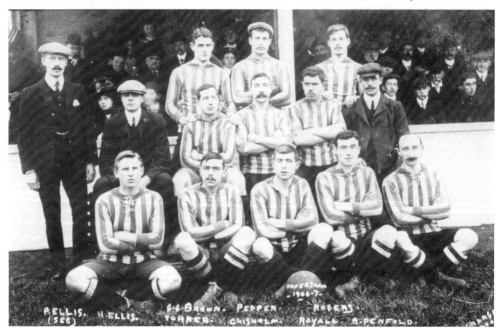

Faversham Town Football Club's players and officials in 1906-7 season. Back row, left to right: G.C. Brown, Pepper, Rogers. Middle Row: P. Ellis (secretary), H. Ellis, Turner, Chisholm, Royall, A. Penfold. Front row: Church, Lightfoot, Cummins, Whelam, C. Wilkinson.

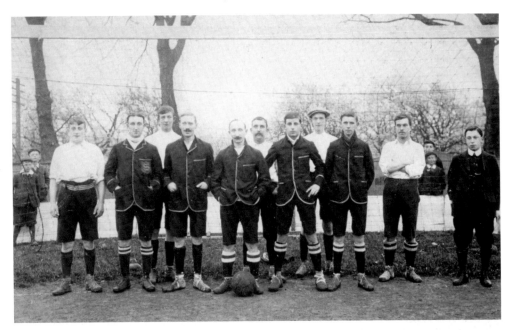

Shepherd Neame's team for the brewers charity match on 25 April 1907. The players – looking rather smart – are kitted out in leather boots, long shorts and blazers.

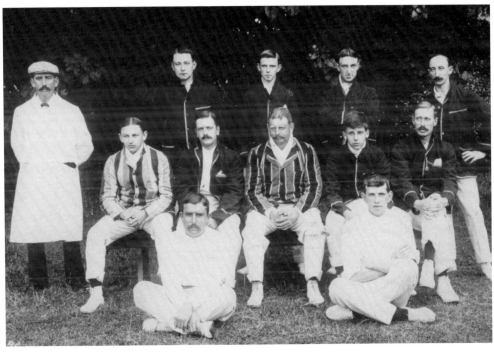

Shepherd Neame Cricket Club in 1906. Sport must have played an important part of social life for the employees of Shepherd Neame in the first part of this century. Looking sombre – perhaps they lost – the players line-up for the camera of William Hargrave.

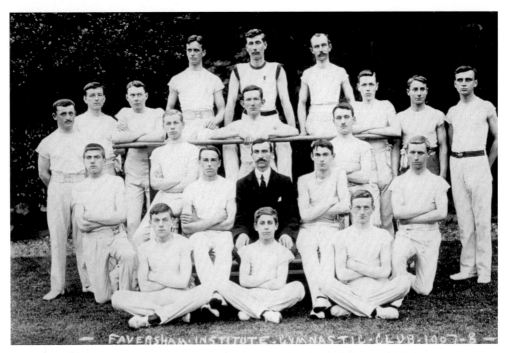

Members of Faversham Gymnastic Club pictured by W. Hargrave, 1907-8. The club was run by Mr W. Carter for many years at the Institute in East Street.

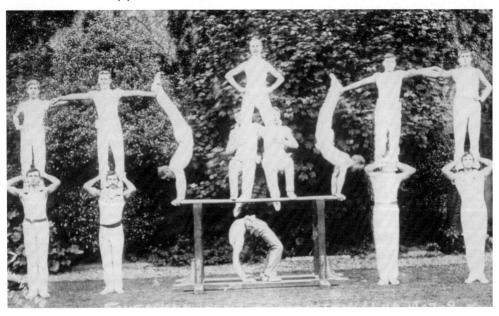

Pictured in the grounds of the Faversham Institute, men and boys of the club display their athletic prowess for the camera, 1907-8. The Institute was demolished in 1979 and on its site John Anderson Court, housing for the elderly, was built by the Hanover Housing Association in 1985-7.

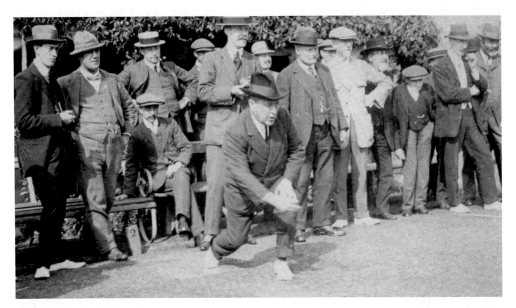

Faversham Conservative bowling green opening, *c.* 1910. Mr Watson-Smith plays Mr Granville-Wheler on a green situated at the rear of The Market Inn in East Street. The green was small and did not come up to the high standards required for the game. Thus the club could not at the time of its formation apply for affiliation to any bowling association.

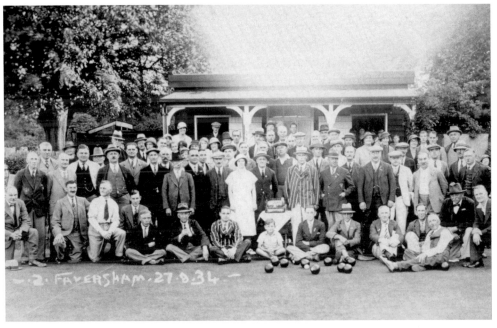

Members of the Faversham Bowling Club outside their original pavilion in the recreation ground on 27 September 1934. The very first pavilion, a wooden shed measuring only 21 feet by 11 feet and bought secondhand from the disused Cotton Powder Works at Uplees for £50, is still the centre of the bowling club's greatly extended premises.

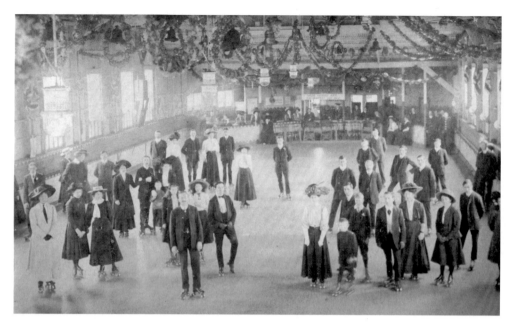

Faversham skating rink opened in January 1910, with the motto 'Skate to be graceful'! B. Anderson of Faversham put in a maple skating floor, lounge, refreshment buffet and an orchestra gallery, and it was opened by C.L. Watson-Smith, with the support of the Member of Parliament, Mr Granville-Wheler, Alderman H. Child and Councillors E.F. Fuller and L. Jackson, and an exhibition of trick and acrobatic skating was given.

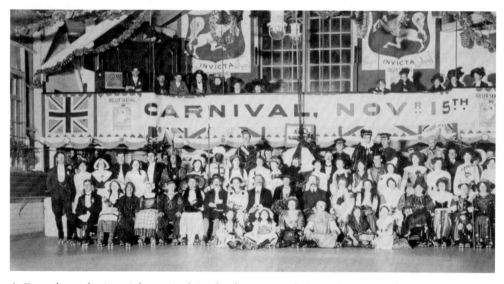

A Faversham skating rink carnival in the first year of the rink, 1910. The rink was in the converted shed of Osborn Dan, barge builder and repairer at Creek Head, with the main approach from town over the creek swing bridge. The building was destroyed by fire in 1925 and facilities at Herne Bay were used for some years. Faversham were world-beaters in rink hockey, played on roller skates, in 1930 (see page 76).

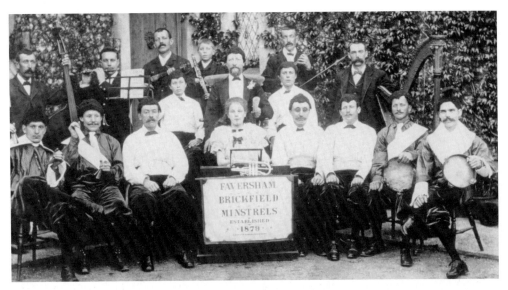

The sign in front of the musicians proclaims that the Faversham Brickfield Minstrels were established in 1879. On the left of the picture, holding a double bass, is Thomas Goodwin who was a brickfield worker who later took over the Brents Tavern in Faversham, and then ran the Three Mariners at Oare throughout the First World War and until around 1924.

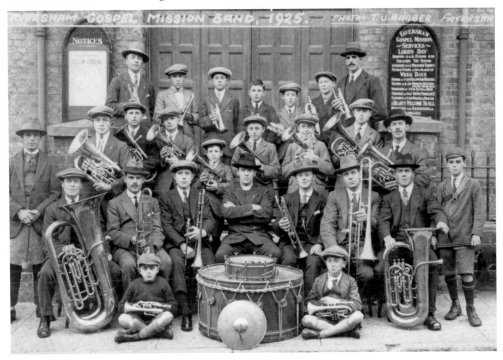

Faversham Gospel Mission Band outside the Mission Hall in Tanners Street in 1925. The Mission Hall, along with the Temperance Villa next door, was erected in 1889. The hall stands on the site formerly occupied by Napleton's Hospital (or almshouse) on what was known as Tanners' Green.

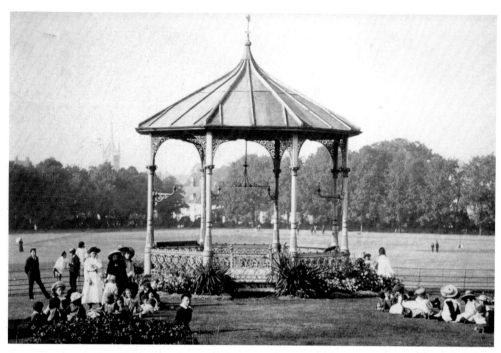

General view from the terrace on which the opening ceremony of the Recreation Ground took place in 1860, showing the lawn and flower beds, the bandstand (1895), some of the playing area with the church spire surmounting the trees, with the top of Rigden's brewery to the left.

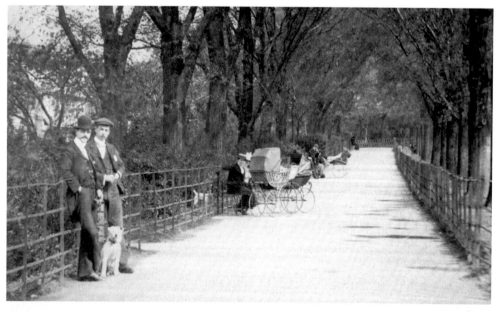

Faversham recreation ground, *c.* 1906. A fine view of the tree-lined avenue with two gentlemen and their dog and Edwardian mothers with perambulators, out for a promenade. Note the iron fence used to enclose the shrubberies which has long since been removed.

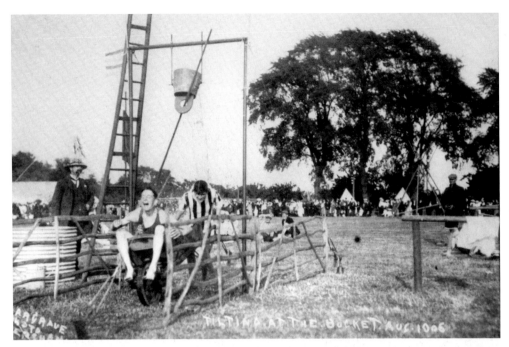

People here are tilting the bucket during a sports day at the Faversham recreation ground in August 1906. Players laugh as they dodge splashing water, it appears to involve knocking over a bucket of water without getting wet. Hundreds of people line the rec – at a safe distance! – to watch the proceedings.

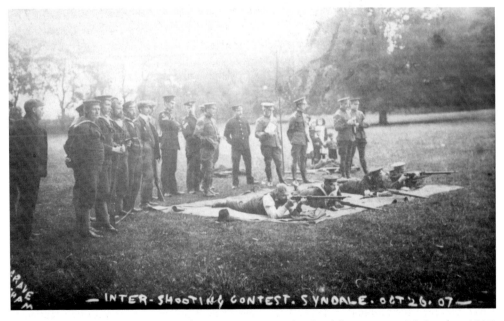

Competitors line up for the inter-shooting contest at the Syndale range on 26 October 1907. There is no indication of how the different factions got on or who came out on top.

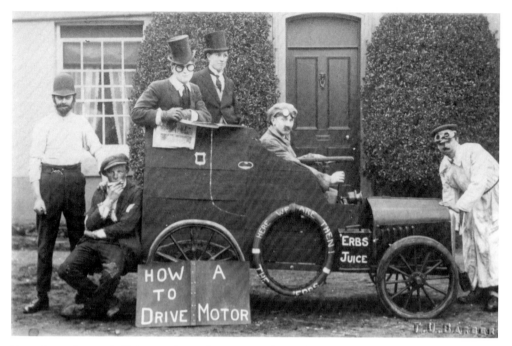

Faversham Carnival Club was formed in 1890. The highlight of the year was the torchlight procession held on the first Thursday nearest to the fifth of November. A lot of thought and artistry was put into the building of the cars. The entry for the 1922 carnival pictured above, with characters out of a comic book, shows a motor car that ran on 'Erbs Juice'.

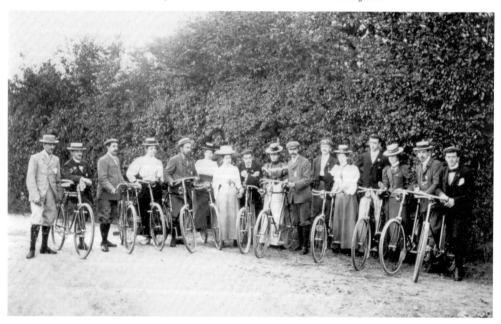

Faversham Cycling Club members in 1898. The cycling outfits worn in those days could provide a model for entrants in various categories of fancy-dress competitions today.

Hop-Picking and Country Life

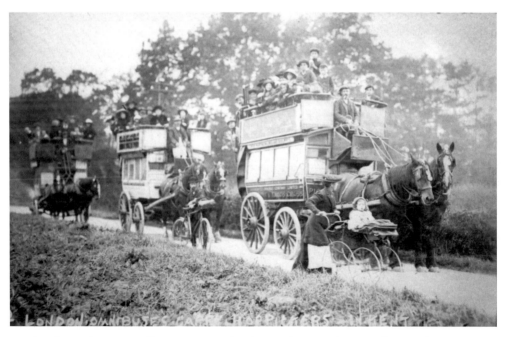

London horse-drawn omnibuses transporting hop-pickers to the Kent hop-gardens, *c.* 1905. When the hop-picking season came, the Town Crier would go round with his bell announcing to the resident pickers the time and places when picking would commence and where to leave their baskets for the farm wagons to collect.

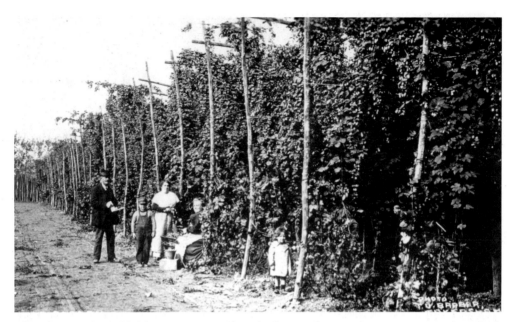

The Tally Man has added his own personal bit of colour to the scene by wearing a new hat which is the sign of authority. The Tally Man or Booker, always a trusted worker, required some binmen to help him manage the garden, one man to every sixteen baskets, so he would have had five or six helpers.

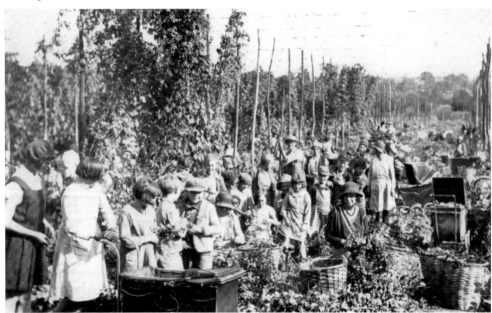

Women and children pictured in a hop-garden near Faversham during the hop-picking season, *c.* 1920. In addition to earning some much needed money, it was usually the only opportunity for the city dwellers and their families to get some fresh air and a taste for country life. They would join up with local people and everyone, including the young children, helped to bring in the crop.

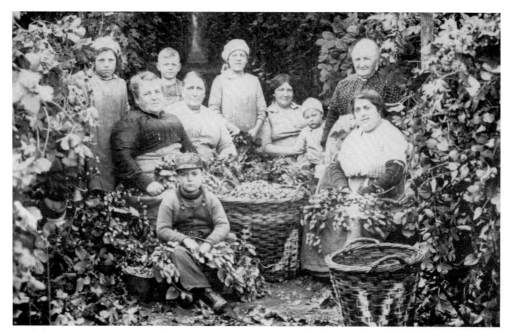

Whole generations of families would join up for hop-picking and they thought of themselves as little communities whose reputation travelled far and wide. Many returned to the same farms and when the day's work was done they would sit around camp fires, exchange news and sing songs.

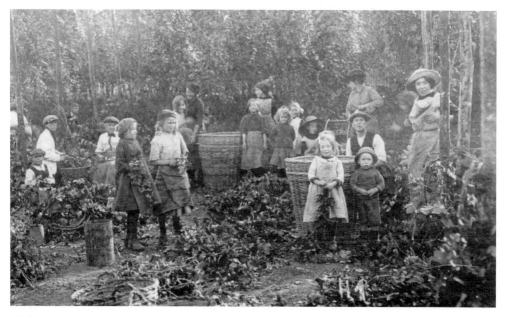

Children among the bines and baskets in the Boughton area in 1913. Around Faversham, six-bushel baskets were used, not bins. When enough to fill the tally was reached a Tally Man would go round with the horse and wagon and the hops would be shaken in the tally-basket from bushel baskets.

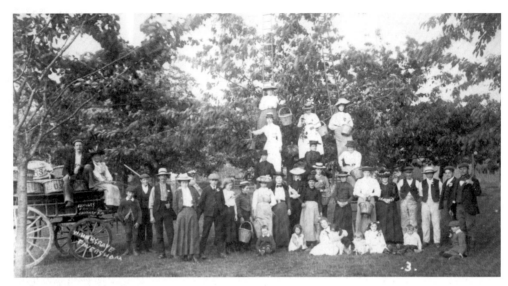

Cherry picking near Faversham, *c.* 1906. The pickers, with a wide assortment of hats, and the ladies, wearing long skirts, must have found it hard work climbing those tall ladders. Modern fruit-growing practice favours smaller trees accessible from the ground or at least from much smaller ladders than those seen here.

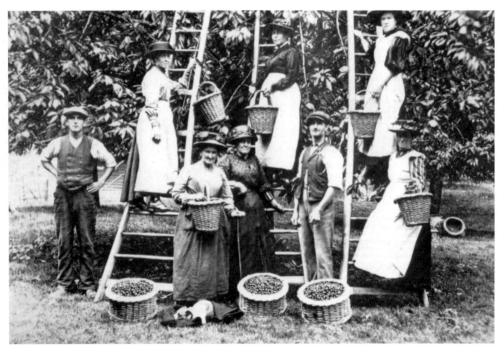

Baskets at the ready to gather in the cherry crop at Teynham, at the turn of the century. In 1533 Henry VIII gave his fruiterer, Richard Harrys, a farm in Teynham which Harrys planted with cherries. The cherries referred to were first planted near the stream by Ozlers Farm and were found to do so well there that Harrys made a bigger plantation at New Gardens.

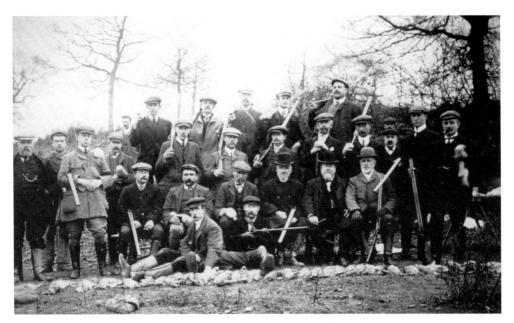

Mr W. Clark's rabbit shoot on 11 February 1908. After a successful day's shoot, the party, with their ferrets and double-barrelled twelve-bore guns, line up to have their photograph taken with the tally.

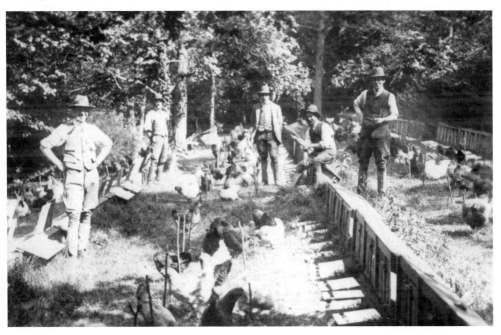

Gamekeepers and estate workers lovingly tend their broody hens sitting on pheasants eggs in 1914. Bred for big shoots at Lees Court, the home of Earl Sondes, the pheasants were released in woods on the estate. Beaters were employed to drive them out into open fields where the shooting party, with their guns, would be waiting.

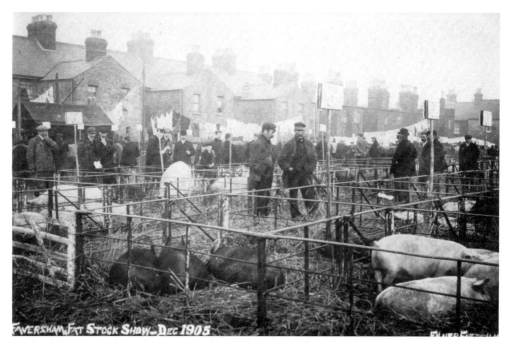

Faversham Fat Stock Show in December 1905. The cattle market, situated behind houses in Whitstable Road and Westgate Road, was held on alternate Tuesdays, and was usually well attended. Quite a lot of people kept pigs in their backyards and friends and neighbours would give their leftovers to help with the swill. Somehow there never seemed too many complaints about the aroma of pig and if there were, no one took any notice!

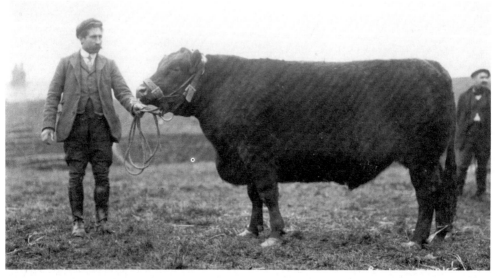

Faversham Fat Stock Show champion beast for Mr W.W. Berry in 1913. The market closed and East Kent Packers Limited expanded by occupying the site for many years. The premises were sold and houses of Bob Amor Close built on the old cattle market site.

Farmers at the Faversham ploughing match on 1 November 1911. On the day of the ploughing match there were usually classes for the best turned-out team of horses and sometimes show jumping was an added attraction.

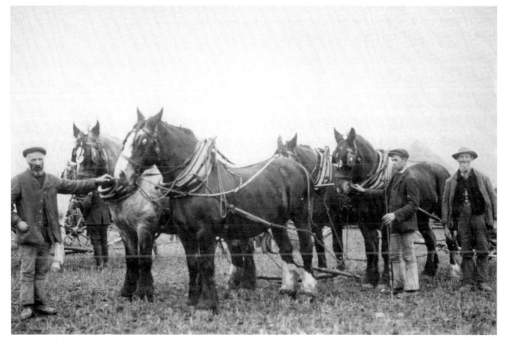

Little has changed in the appearance of the magnificent heavy horses which took part in Faversham ploughing match in 1912, but the dress of their handlers is quite different from that to be seen by those who carry on the old skills today.

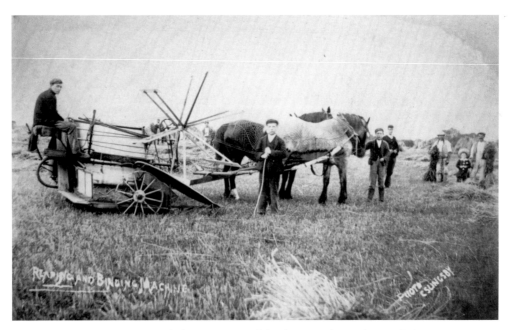

Harvest time, *c.* 1905. Around the reaping and binding machine, that tied the cut corn into sheaves, the whole family work hard at getting in the harvest while the weather holds. Notice that some of the men have their trousers tied just below the knee, to prevent mice running up the trouser leg.

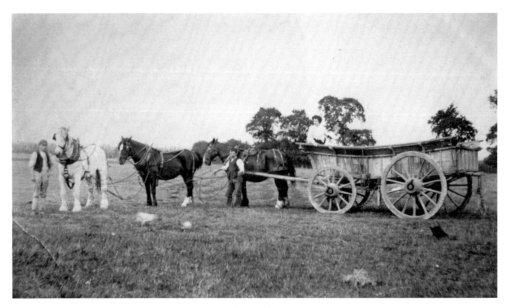

The wagon was the backbone of every aspect of farming. Built almost entirely of wood, it consisted of a four wheeled flat bed with sides only a foot or so high. The Kent Wagon can be easily recognised by the pole at each corner, instead of the gate at each end that was found on wagons from other parts of the country.

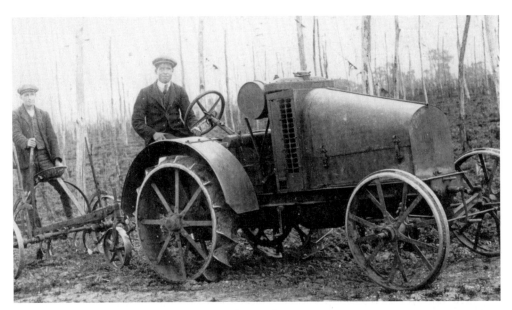

The tractor pictured above, in a hop-garden near Faversham, is an American built International Harvester. The model is the 8.16 which was in production from 1917-22 and was fitted with an overhead valve four-cylinder vertical engine with a three-speed gearbox with a top speed of four mph. The plough behind the tractor is a horses-drawn shim, probably converted for tractor use.

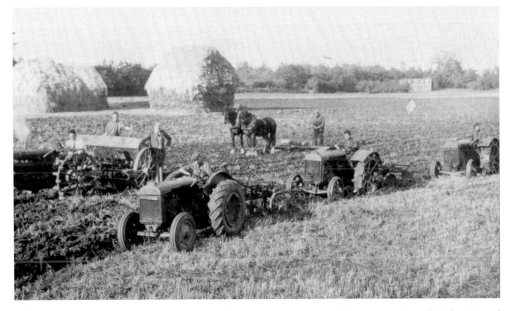

Working the land with horses and tractors on a farm in the Faversham area just after the Second World War, a once-common scene, no longer to be found. On the left, driving the tractor, is Mr Harry Bolton who had a farm at Uplees. Standing on the machinery behind the tractor is Mr Horace Lennard, my grandfather's brother, and supervising the whole operation is Mr Harry Knowles, who had a fruit and vegetable shop at 79 Preston Street (see page 25).

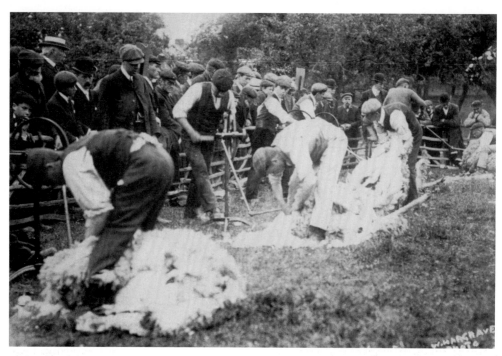

Up-to-date sheep shearing at Faversham on 12 June 1905. At one time, the sheep were clipped by hand, a time consuming job, before the hand-cranked clipper was developed – which was good for small flocks out in the field.

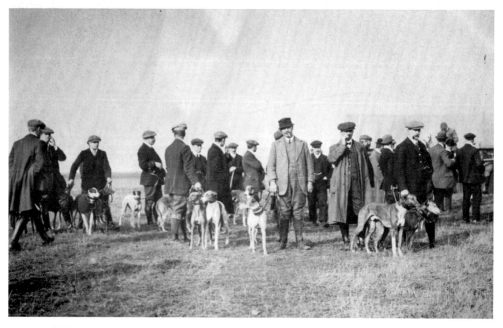

Resting the dogs after coursing, at Luddenham on 13 February 1911. The sport of hunting with dogs trained to chase game by sight instead of scent is now illegal.

Ospringe and Whitehill

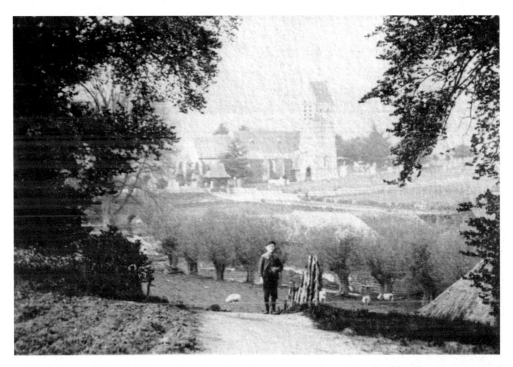

From the top of Vicarage Lane there is a fine view across to Ospringe church. The view pictured here in 1904 shows sheep grazing by the willows lining The Brooks, with Queen Court Farm lying in the hollow. The willows and The Brooks have disappeared as have one or two buildings, but the overall view is much the same.

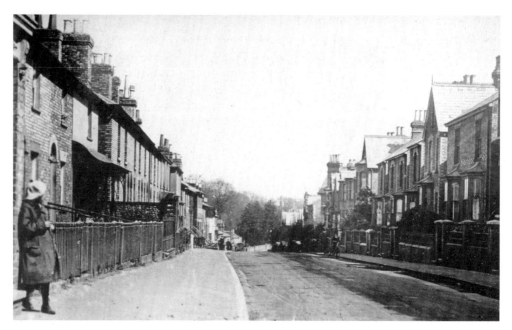

Ospringe Road, *c*. 1913. Little would the girl in the photograph have dreamt that, sixty or seventy years later, the quiet town road would be full of parked cars! Horse and cart was the means of transporting goods in those days.

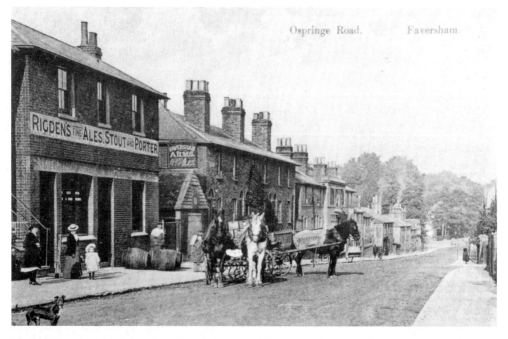

The second picture of Ospringe Road shows a delivery to the Faversham Arms around 1906. The fact that the horses pulling the drays are standing at an angle to the kerb suggests traffic conditions were fairly light and the area was a lot more peaceful than it is today.

This photograph, taken from a glass negative, shows two fascinated youngsters standing in front of houses on the corner of Cambridge Road and Ospringe Road, *c.* 1905. The buildings on the right of the picture are the premises of Ospringe Model Laundry Company, dyers and cleaners.

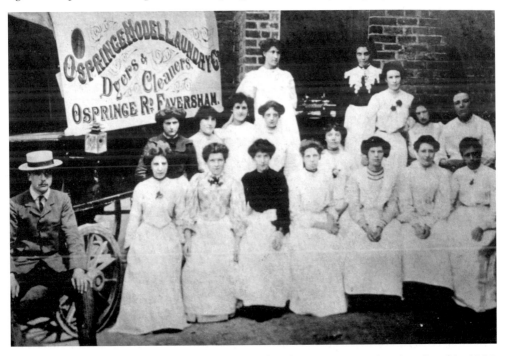

The staff of Ospringe Model Laundry seated outside their premises in Ospringe Road in 1906. The laundry closed and Wyard's Printing Works has occupied the site for many years.

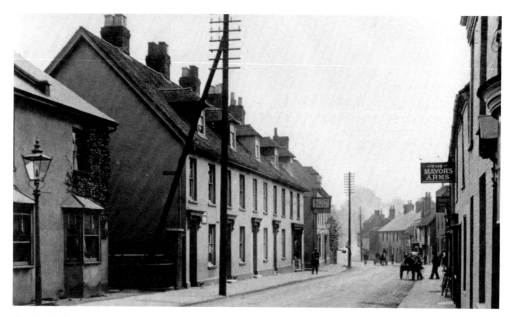

Ospringe Street, *c.* 1913. The sign of the now defunct Mayors Arms can be seen on the right, while on the left a sign advertising the Lion Inn juts into the street. The Anchor Inn, which can be seen further along the terrace on the right, is the only one still in business, although it no longer functions as a coach station.

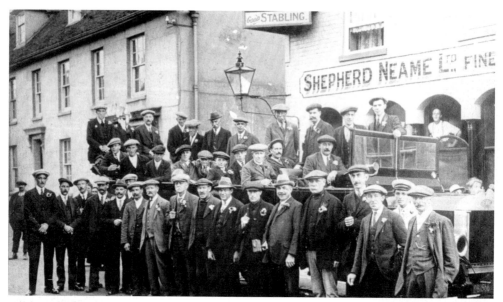

Customers of the Lion Inn in Ospringe Street about to leave on an outing in the 1920s. Advertising good stabling, the Lion Inn belonged to Shepherd Neame Limited of the Faversham Brewery. The London Road has passed through the village of Ospringe since Roman times, and has always been busy – by 1830 four stagecoaches a day, six days a week, ran through the village between London and Canterbury.

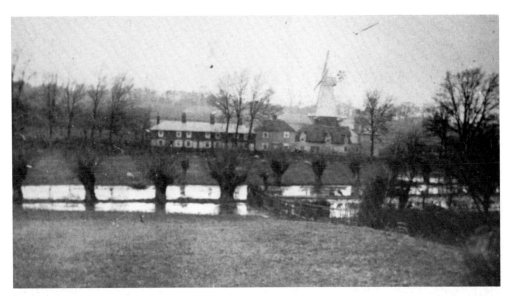

The Brooks Water Lane, Ospringe in 1905. The windmill, seen across the stream, was a remarkable mill for the height of the gallery (stage), mounted on an octagonal brick base of three storeys, with a rather elegant arched doorway. Edward Packer was the miller here in 1878 according to an old directory. Not long after this view, the mill did not pay its way, ceased working and was pulled down around 1915.

A black cat brings luck to Mill Place and Dawson's Row in Water Lane, Ospringe, c. 1913. Further along Water Lane is the parish church of St Peter and St Paul, built largely of flint with a plain tiled roof. It dates from 1200, although the fourteenth-century chancel and other details were considerably rebuilt and restored in the late nineteenth century.

A wonderful scene, taken around 1905, shows three little girls playing at Whitehill. The hamlet of Whitehill is located about a mile southwards of Ospringe, following the road to Painters Forstal, in the valley through which a rivulet took its course.

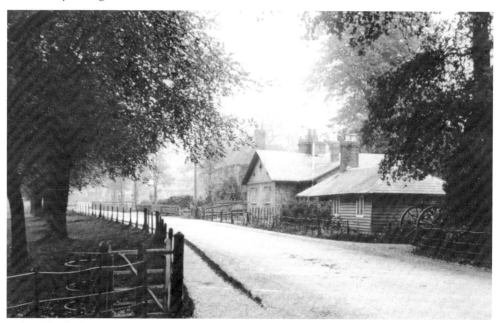

The scene at Whitehill, on the road between Faversham and Painters Forstal, in the tranquil days before the car was king, *c.* 1916. At the foot of Whitehill lies Whitehill House, a hall house dating from 1430, but re-fronted in the late eighteenth century with yellow mathematical tiles under a slate roof.

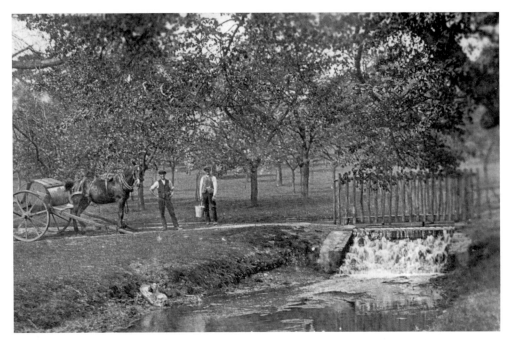

A horse-drawn watercart is filled from Whitehill waterfall on the Lorenden Estate in 1918. Edward Jacob, the Faversham historian, lived at Lorenden in the eighteenth century. The house has changed greatly since his times.

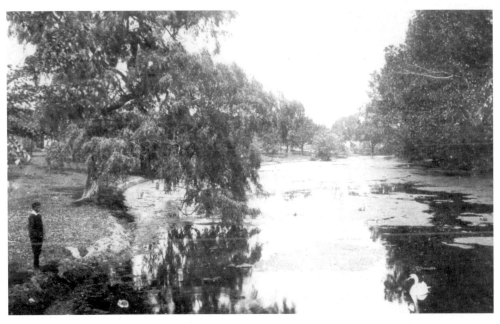

Willows line the banks of the pond at Whitehill, Ospringe in 1905. Note the young boy to the left of the picture and the swan to the right. The Whitehill Lake on the Lorenden Estate used to be quite a large lake which was formed as a feature of a natural high water table.

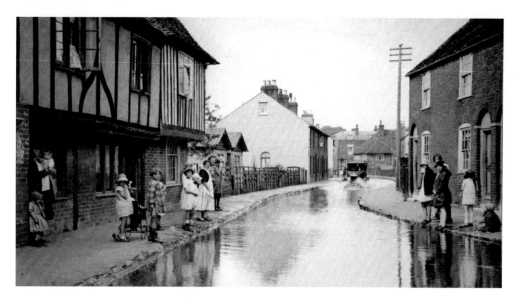

Water Lane, Ospringe, c. 1926. The children standing on either side of the stream are perhaps hoping for the car to cause some excitement by splashing them with water. Newcomers to the Faversham area are frequently curious to know the origins of the name Water Lane off Ospringe Street. This was associated with a nailbourne (an intermittently flowing chalk stream) which sometimes ran from Kennaways into the lake at Whitehill and from there to Faversham Creek, via Water Lane and the Davington Ponds.

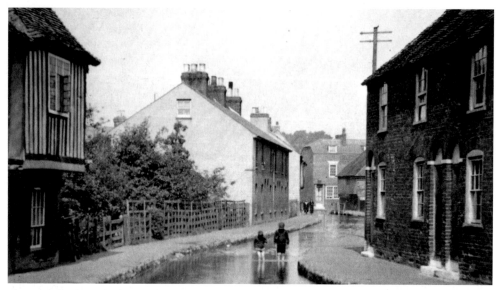

Water Lane, Ospringe, c. 1918. Those were the days when youngsters had to find their own amusement in the long school holidays – the days when swimming pools were the exception rather than the rule and trips to the seaside were eagerly anticipated weeks in advance. In June 1962, drainage for the M2 motorway was laid, the stream culverted and Ospringe lost for ever its 'Little Venice'.

SECTION NINE

Oare and Harty Ferry

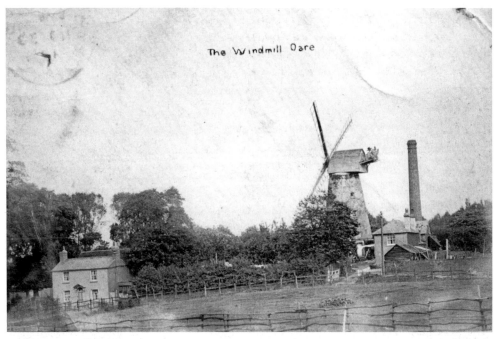

The photograph, taken from what is now BOC Transhield's carpark, shows Mill House on the left and the windmill, Oare, *c.* 1916. Erected in the early years of the nineteenth century, this five-storeyed brick tower mill was a fine specimen in its day, well built, splendidly equipped and the motive power of a large business, working four pairs of stones. The Luddenham tithe map of 1841 states that the mill, cottage and garden, owned by John Davies and run by a Mr Kennett (no relation to the author), stood in the portion of Luddenham parish situated between the road from Faversham to Oare.

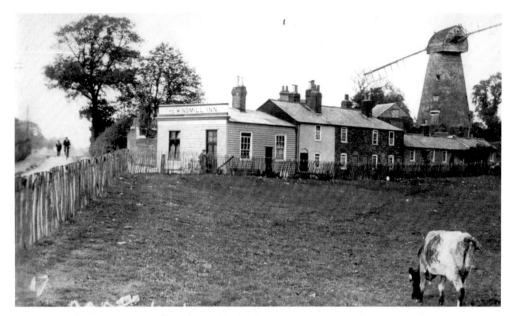

The Windmill Inn at Oare, in the shadow of the mill, on 20 March 1927. The mill fell into disuse after the First World War and probably escaped demolition because it was considered a necessary landmark for mariners from Oare and Faversham Creeks by Trinity House. It was converted into a house in the 1960s.

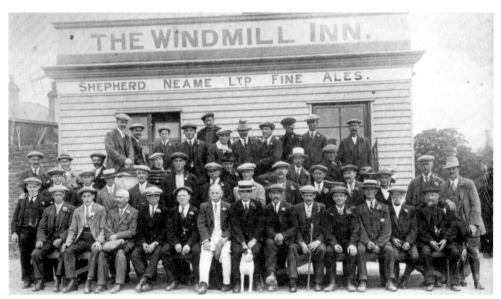

A flower in every buttonhole and a cap or hat on nearly every head, as forty-five men and a dog pose before their annual charabanc outing seventy-six years ago. The picture was taken outside the Windmill Inn, Oare Road, Oare in 1920. Most of the men in the picture worked at Cremers' brickfields on the other side of the road. My grandfather, Jack Lennard, is included in the line-up, second from the left in the second row.

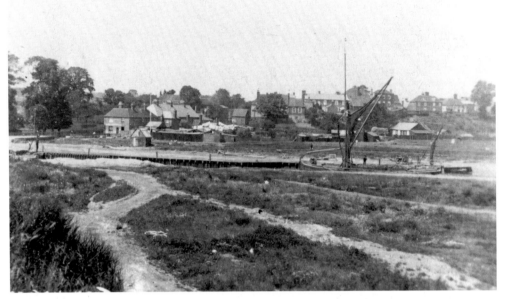

Oare Creek, between the World Wars, shows a Thames barge moored. The scene is now the site of Young's Marina. Gunpowder manufacturing works and brickmaking were responsible for the importance of Oare Creek in the late nineteenth century and the first quarter of this century.

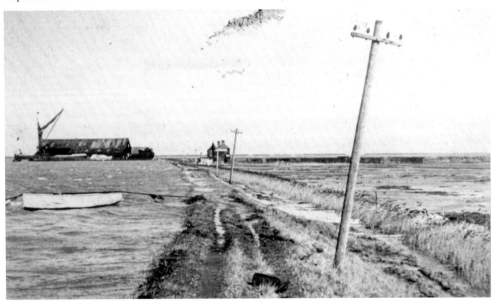

An abnormally high spring tide in Oare Creek floods the surrounding marshes at Hollowshore in March 1949. In the distance on the right is the Shipwrights Arms public house. On the left stands the Hollowshore yard, at the junction of Oare and Faversham Creeks, which was owned by Cremer who, besides repairing his fleet of barges, built three good-looking barges for his fleet; the *Nellie* and the *Bertie* both of forty-three tons in 1901 followed by the *Pretoria* of forty-four tons in 1902.

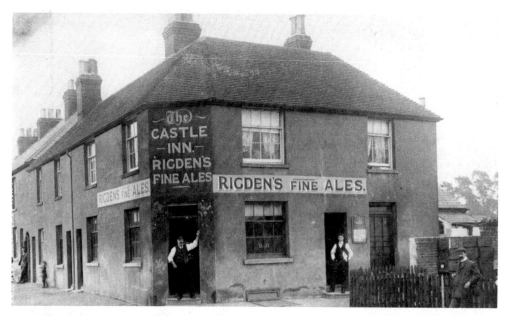

The Castle Inn in Castle Row, Oare, *c.* 1906. The gentleman standing in the doorway of the Castle Inn is the licensee, James Busbridge while in the doorway on the right is his son, Percy Busbridge. The pub was a beer and ale-house only at the time – it carried no spirits' licence.

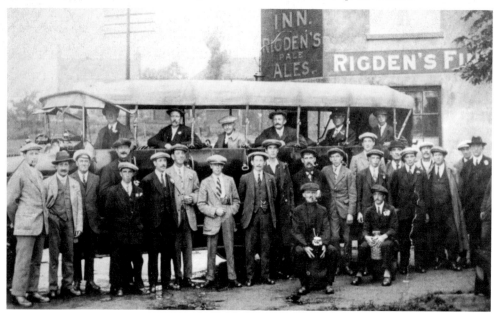

The Castle Inn at Oare was a popular watering hole among workers at the Faversham brickfields, gunpowder factories and men earning their living from Oare Creek. A group of customers are pictured outside the pub before setting off for a charabanc outing in 1926. Among the group are: Tommy Cooter, Jack Ramsden, Joe Epps, Jimmy Raines, Albert Ramsden, Perce Harris and my grandfather, Jack Lennard, standing third from the right.

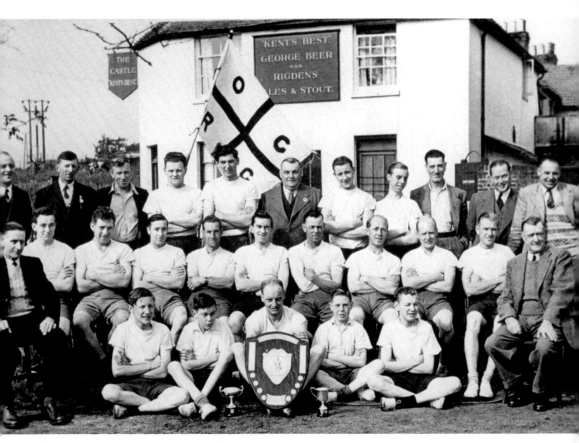

The Grand Old Master of goal running in the Faversham area was Percy Busbridge. In 1907, at the age of eighteen, he was a founder member of the Oare Goal Running Club (see page 110 top). Around 1950, owing once more to the initiative of Percy Busbridge, a Faversham Goal Running League operated for a few years. Perhaps the high spot was 1951, when the Festival of Britain was the occasion for a competition for a challenge shield. The final between Faversham and Oare, the latter winning the shield by five strokes, was played on the recreation ground. The victorious Oare side are pictured outside the Castle Inn, with their challenge shield, in September 1951. Back row, left to right: Ralph Charman (landlord), Fred Willis, Horace Lennard, 'Buster' Young, Michael Spice, Alf Young, Ted Medley, Jimmy Smith, Phil Spice, Cyril Ruck, Harry Bolton. Middle row: Joe Goodwin, Tony Sweeting, John Foster, Jack Turner, 'Tut' Lambert, Dennis Cotton, Bill Willis, Fred Sears, Howard Heathfield, Les Allchin, George Ramsden. Front row: Sid Medley, Geoff Spencely, Cecil Worsley, John Sears, Dennis Mummery.

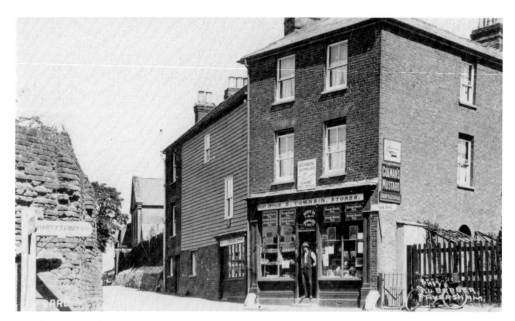

Standing in his shop doorway, Sam Townsin poses for Faversham photographer T.U. Barber in 1923. Oare post office and stores were situated opposite the Three Mariners on the comer of Church Road and Chapel Road. The shop sign above the door reads: 'Seamen supplied at any time day or night'. Mr Townsin was a happy man who ran a very popular village store.

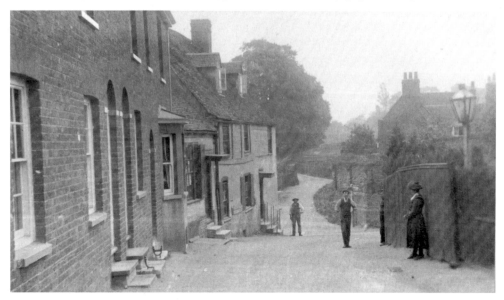

Looking down Church Road towards the Three Mariners in 1908. Brickmaking was a major industry in Oare in the nineteenth century. It was essential, especially in the early days when brickfields were expanding, to provide dwellings for the workers. At Oare, in 1870, Amos built a row of houses for his workers. Pleasant Cottages in Church Road and a row at Russell Place were built at the same time to accommodate workers in adjoining fields.

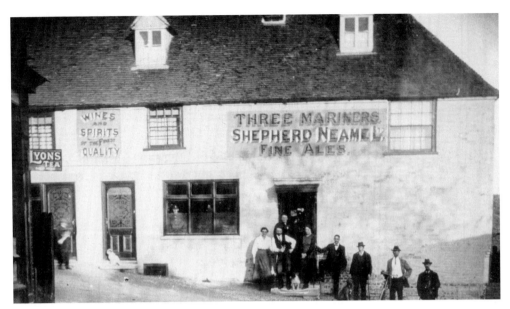

Who were the three mariners giving the pub its name? Nelson, Drake and Hood? Nelson is known to have been in Faversham on at least one occasion. Standing outside the Three Mariners, landlord and landlady Thomas and Annie Goodwin are on the left of the group with their jack russell dog. They ran the Three Mariners until around 1924.

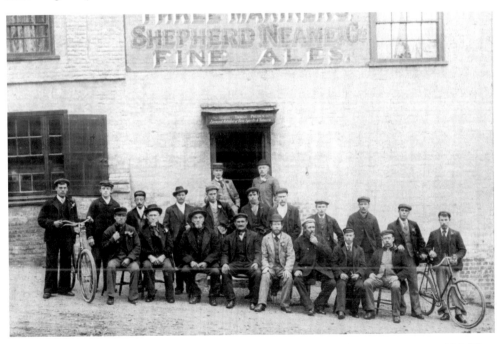

Pub regulars pose for the camera of Frederick Austin outside the Three Mariners, c. 1908. They are all wearing their Sunday best – hats, ties, buttonholes and shiny boots. Did they dress up specially for the photograph or were they off on a pub jaunt?

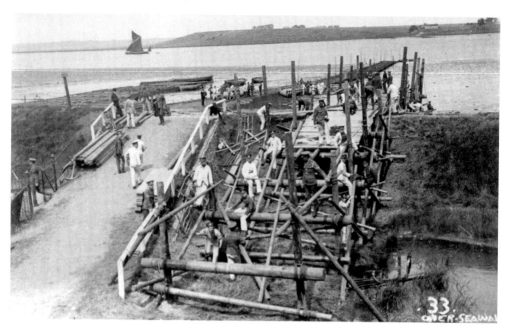

In the summer of 1910 – four years before the outbreak of the First World War – the Royal Engineers camped at Oare to take part in an exercise at Harty Ferry, building a 1,200 yard-long wooden pontoon bridge across the Swale to Sheppey.

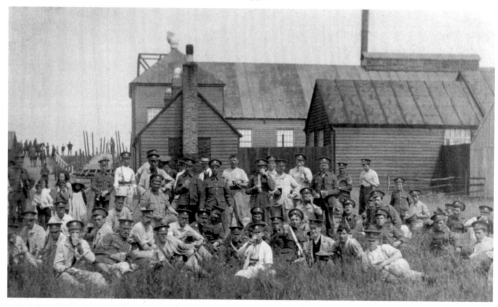

Sappers take a well earned rest and refreshment outside the Eley Bros., fulminate of mercury explosive works (The New Found Out) at Harty Ferry. These men had the specialised and important task of constructing a bridge to span the Swale from the Faversham side to the Isle of Sheppey, which would facilitate the passage of troops in and out of the island and provide the Kent Fortress engineers with vital practice.

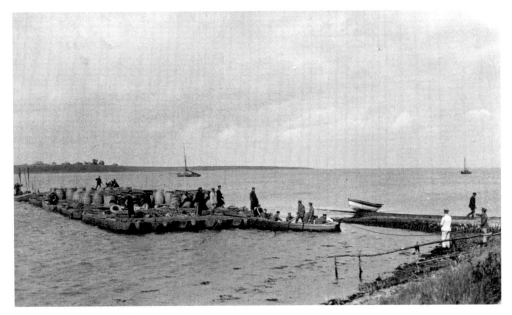

The bridge-builders spent the first few days unloading and dismantling a large fleet of pontoons which had been towed round from Chatham and brought alongside Harty Hard. Material unloaded from them was placed in a field behind the coastguard station's boathouse.

Some of the Royal Engineers were members of the Territorial Army and the operation, called Kent Fortress, used a total of 250 men. The crossing of the Swale was made by about 2,000 men of the 4th London Brigade using 30 wagons and 140 horses, and conditions were described in the Royal Engineers' journal as: 'A strong southwest wind which created a strong swell.'

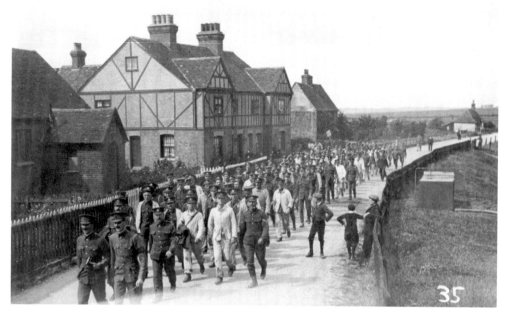

Boys come out to watch as the soldiers return from the bridge site along Church Road, Oare. Major J.C. Matheson wrote that the bridge, when finished after 10 days' work, on 2 August, was 1,200 yards long from bank to bank.

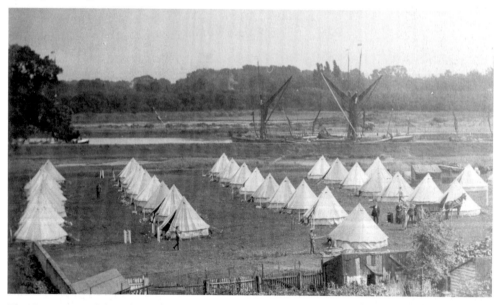

The Oare camp of the territorials in 1910, showing the creek with a number of barges, and in the foreground some horse transport. The site on grassland below the head of the Creek was close to the Castle Inn. The retail business side of Faversham is said to have benefited considerably from this visit of the territorials, for hundreds from the Oare camp are said to have come into the town in the evenings.

SECTION TEN

The Villages around Faversham

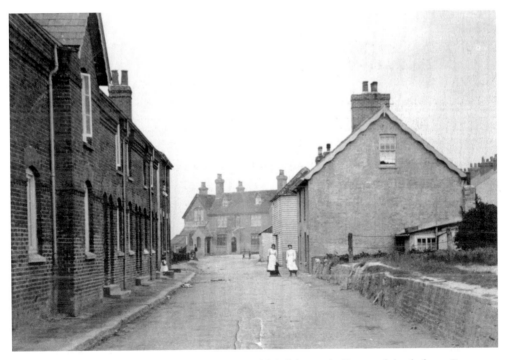

Looking down towards the Ship Inn, Conyer, *c.* 1906. A long winding creek leads from Conyer to the River Swale and there is a long mud island called Fawley Island (still the resort of sea birds) off the mouth of this creek.

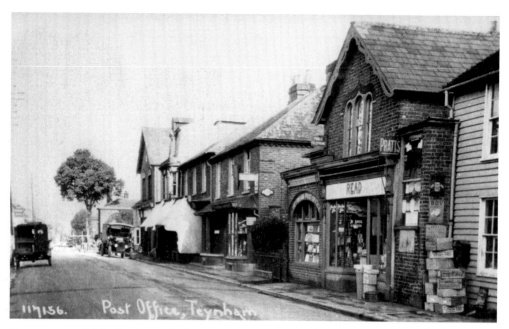

Greenstreet, *c.* 1925, showing parked cars near the post office whose proprietors were Read and Son. To the north, Teynham extends to the marsh land by the River Swale and the navigable creek at Conyer. In the reign of Henry VIII, Richard Harrys, the King's fruiterer, planted 105 acres of rich land with 'sweet cherries and pippins from beyond the sea' – the introduction of the Flemish cherry to Kent.

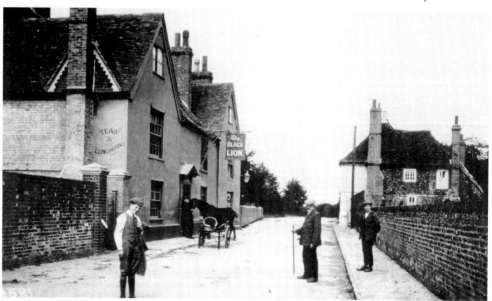

The Black Lion, Lynsted, *c.* 1912. Until 1939 there was a 12 mph speed limit in the village! The church, dedicated to St Peter and St Paul, stands in the street and is built largely of flints with a tower surmounted by a shingled spire. The parish continues to the south side of the A2, where the London Road at Greenstreet forms the boundary between Lynsted and Teynham.

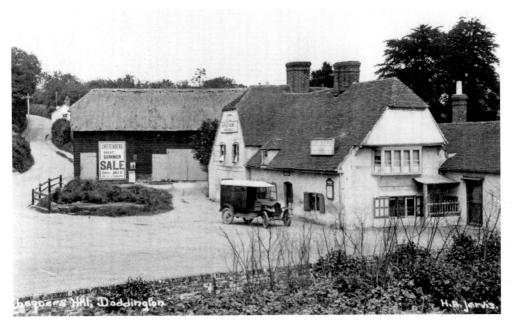

Chequers Inn, Doddington, *c.* 1918. The old barn beyond was used for village functions. The poster is advertising a sale at Crittendens of Sittingbourne. The long roof of the inn may have been used as a smugglers' 'cache'. Doddington church stands on a hill and is dedicated to St John the Baptist.

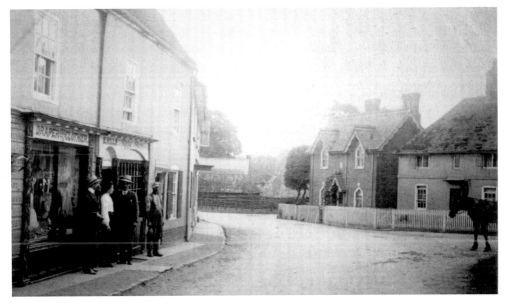

Time for a chat outside E. Hills 'Supply Stores' in Newnham at the turn of the century. In the street stands the church, dedicated to St Peter and St Paul, and part of the endowment of the Nunnery of Davington from 1153 to 1538. Just beyond the church is Calico House, formerly the old parsonage.

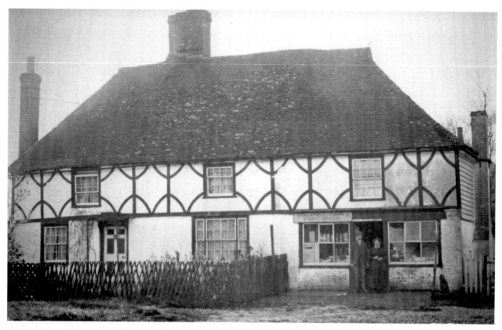

The post office at Stalisfield Green, *c.* 1930. At the highest point in the old Swale rural district is Stalisfield, where the surrounding woodlands surge to a height of more than 600 feet, and the air is still sweet with the scent that downsmen have loved for thousands of years.

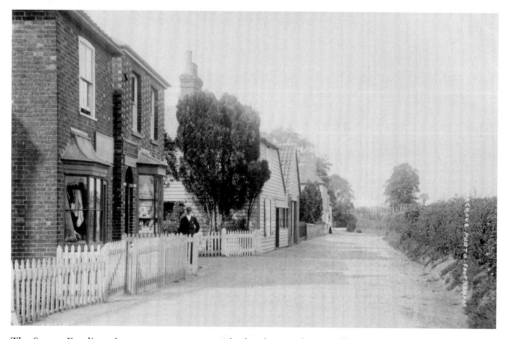

The Street, Eastling. A customer poses outside the shop and post office of T.J. Doughty in 1906. A hamlet of delight in the high country of the North Downs, every year at the beginning of May the shingled spire of the church stands out at a distance like a ship's mast rising from a sea of foam.

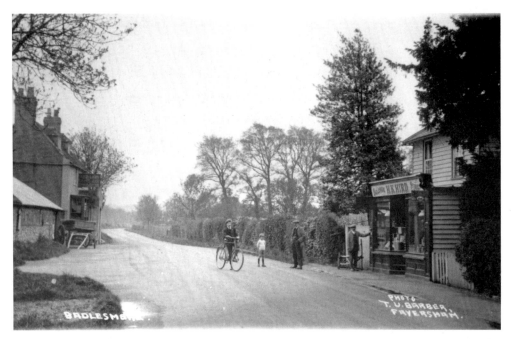

Local people line up across a traffic free Ashford Road, at Badlesmere, for T.U. Barber's camera, *c.* 1926. The heart of the village is The Lees, a green with old houses sited round the edge. Badlesmere church, dedicated to St Leonard, is a Norman building with many 'restorations'.

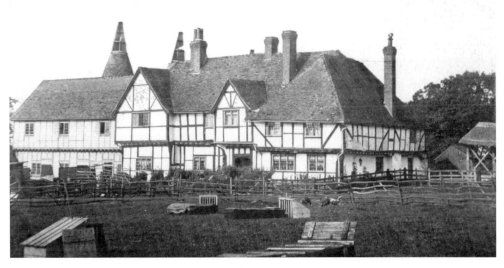

On the west of the Ashford Road is Leaveland, formerly a manor held by the family of Leaveland. The 'Court' or manor house near the church is a good example of the 'black and white' timber and plaster period, *c.* 1905. Leaveland church is a small church, dedicated to St Laurence. In the churchyard, as at Badlesmere, are some fine old yews.

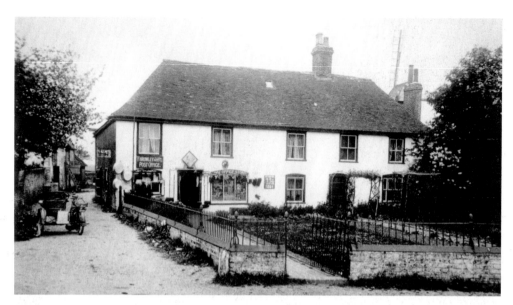

Throwley Forstal post office and bakery shop at Old Barn Cottage, *c.* 1912. Note part of the windmill which can be seen behind the right hand chimney stack. Throwley church, dedicated to St Michael, is large and contains work of Norman and later periods. The Sondes family lived in a manor house, next to the church, until moving to Lees Court, Sheldwich, in 1664. The remains of the manor have long since disappeared. All six chest tombs in the church are monuments to the Sondes.

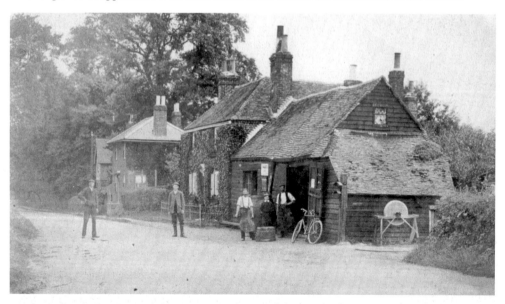

The Old Forge, North Street, Sheldwich, in 1905. Sheldwich lies in delightful countryside off the Ashford Road. The church stands close to the Ashford Road and is dedicated to St James. The great house is Lees Court, the seat of Earl Sondes and was burned out in 1910. The walls were left standing and the house was rebuilt in the classic style designed by Inigo Jones. The house today is divided into residential units in private ownership.

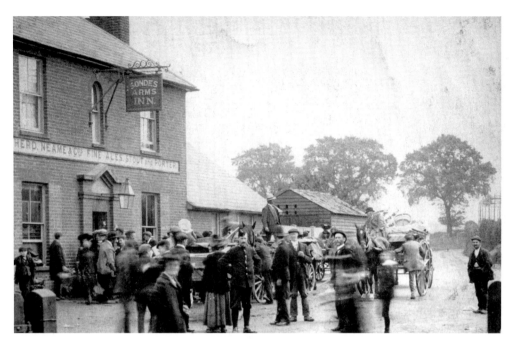

A busy scene outside the Sondes Arms at Selling in 1914. The bustle is illustrated by the blurred images of some of the characters in the foreground – they were clearly too busy to pose for the long-exposure camera.

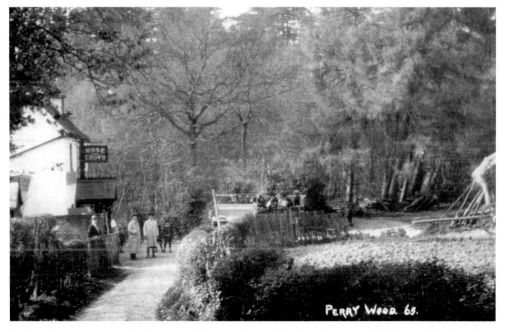

A charabanc outing to the Rose and Crown, Perry Wood, Selling, *c.* 1926. Perry Wood, said to be the site of an early British camp and commanding good views of the surrounding country, is now owned by the Borough Council.

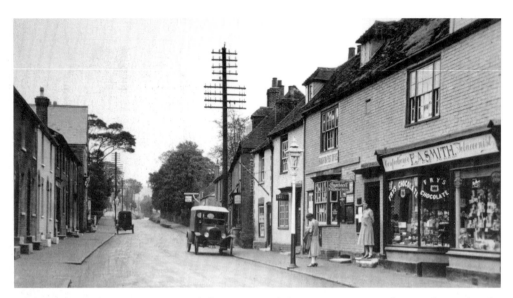

A tranquil Boughton Street, part of the main road from Dover to London, with Smith's the tobacconist, the post office and just two parked cars, *c.* 1930. The thirteenth-century church, with a fifteenth-century tower, stands on a hill nearly a mile from the London Road at Boughton Street and is a beautiful place.

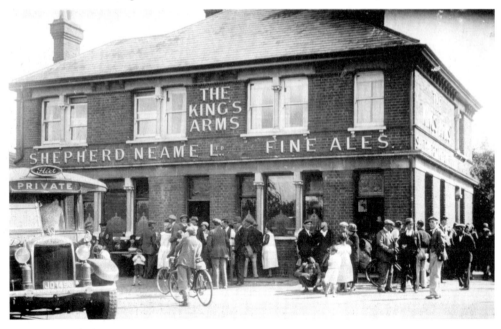

The fortunes of the King's Arms, South Street - an ornate Victorian hostelry with fine column window dividers – were very much linked with hopping. For the brief spell when the hoppers were down, the pub did a roaring trade both in the bar and by supplying jugs and bowls of sheps to be carried back to the hoppers' huts which still stand near Boughton church. Today the King's Arms is a private house having closed in the late 1970s. The last landlord was Terry Boost.

Staple Street, Hernhill, *c.* 1910. The Three Horseshoes, hidden from view on the right, is an eighteenth-century inn with landlords dating back to 1758 as the list in the bar testifies. The road to the left, just in front of the group posing for the camera, leads to the village of Hernhill, set in the centre of rolling downs and covered with woods and orchards, which in springtime make the countryside a veritable fairyland of blossoms.

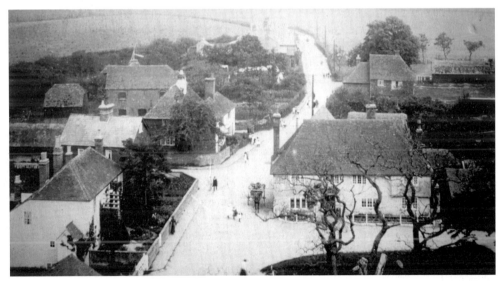

A bird's-eye view of Hernhill taken from the church tower, *c.* 1908. The Red Lion public house is a typical fourteenth-century half-timbered house, with two wings projecting in front of the main building and a roof supported by curved brackets. The inn's charms are enhanced by its position facing St Michael's church and the village green, which is surrounded by picturesque cottages and barns of ancient date.

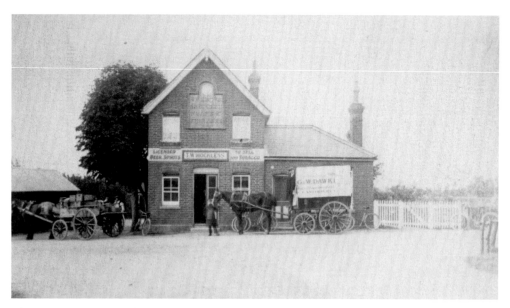

The Dove at Dargate before it was extended, *c.* 1910. The fact that two horse-drawn carts are delivering to the pub indicates the picture was taken either in the late morning or early afternoon. Bicycles parked outside suggest landlord T.W. Hockless had at least five customers at the time and it is more than likely that the delivery men would have downed a pint or two before starting off for their next port of call.

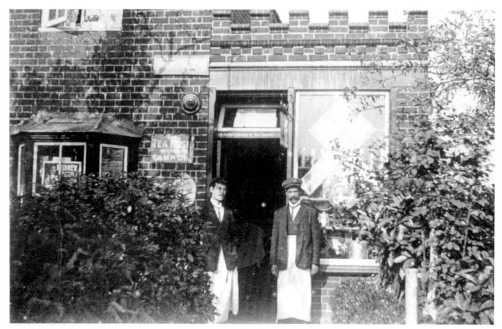

The two men posing in their white aprons ran the Dargate post office which is now closed. The picture was taken in 1913 when village post offices were a vital part of the community. The name above the door is not clear, but could be A. Frear.

Fostall, near Hernhill, *c.* 1910. Beauty abounds in its winding lanes and there is a wide view of the lowland and the sea. Fostall is a hamlet surrounded by some good houses: Mount Ephraim, built in the eighteenth century by the Dawes family, in whose ownership it still remains; Kemsdale, dating from the nineteenth-century; and also Dargate, on the site of a previous manor of that name.

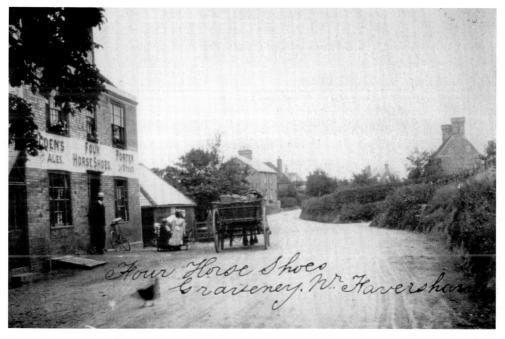

The Four Horseshoes on the Seasalter Road, Graveney, *c.* 1908. Nowadays Graveney cannot boast of being a village – it is scarcely a hamlet – this part of Kent was always sparsely populated but unlike much of the county we can trace the history of Graveney as far back as 811.

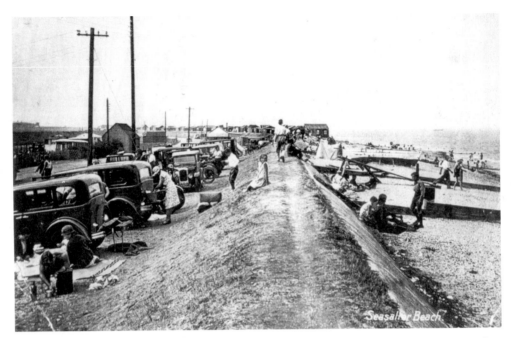

The Seasalter beach around 1945. Seasalter is mentioned in Domesday, spelt Seasaltre, and in old deeds as Seasaltaire. The land belonged to the monks and was let to one named Blize. In December 1763, a live whale, over fifty-six feet in length, was washed ashore at Seasalter.

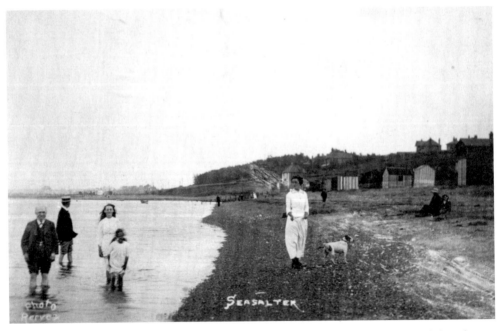

The whole family, including grandad, take a paddle at Seasalter, *c.* 1910. It is said that the sea has encroached on these shores and that the parish church, as well as the village of Seasalter, once stood where now there is only beach.